Unyielding Roots:
WHAT IS YOUR HAIR STORY?

Edited by Kiana Davis

Tree Root Strong Publishing, LLC

Front cover photographer: Sowande Rentando Malone,
Front cover model: Kristina Muckler
Back cover: Photo by Barbara Olsen from Pexels.com

I would like to thank everyone who helped me make this project a reality. Thank you, 4Culture, for the grant and support. I also want to thank all the writers. Your hair stories are so telling, honest, and beautiful. I am so honored to showcase your stories.

CULTURE

This is project was supported, in part, by an award from 4Culture

Unyielding Roots
Kiana Davis

There have been moments
I've felt being natural
was too hard
and my hair
too Unyielding
But I've learned that to understand
Your roots
You must free yourself
From conditioning and programming
that says Black Hair is:
too ethnic,
too thick,
too nappy,
too unkempt,
and you must learn to strip away
the layers of untruths
taught to you from birth
in order to live
unmasked and whole.

TABLE OF CONTENTS

7

FORWARD

Kiana Davis,
Educator, Storyteller/Poet, and author

In 2009, I went natural, and initially, I remember feeling excited and awed at the idea of going back to my roots. "Going Natural" would be the first time I had not chemically altered my hair in my adult life. I had had a relaxer since high school, and before that, I had an S-Curl. However, soon after "Going Natural," my hair and I had a standoff. My hair became an unyielding stranger.

I did not know what it needed, how to style it, or how to keep it from having a life of its own. I immediately noticed that my hair did not care about beauty standards, and it did not care about my mixed-up views on Black hair. My hair, unlike me, knew exactly who it was and how to grow without comprising or apologizing for who it was. I was the one with the problems. I was the one who had to take the time to understand my hair and ultimately learn to understand myself.

It took me several years to truly embrace my hair. As I began to get comfortable with my hair, I saw an increase in natural hair discrimination. In 2013, Twelve-year-old violinist Vanessa VanDyke faced expulsion, and seven-year-old Tiana Parker was expelled because of her dreadlocks. Each year I've noticed story

after story of students being expelled from school and women being fired or reprimanded because of their natural hair and hairstyles. I began to wonder what messaging Black girls and teens were receiving about their hair. And how other Black women viewed their hair, whether it was relaxed or natural. I wanted to know what stories their hair held and how they felt about their thick, coarse, fine, kinky, soft, unyielding, palpable, nappy, medium-thick, wiry, curly, coily, 3b 3c, 4, 4a, and 4b hair.

Lastly, the Unyielding Roots Project will use poetry and storytelling to capture our hair stories. I hope the stories will help schools and businesses to rethink their biased grooming policies. Additionally, I hope this project will help Black women, girls, and teens share and embrace their hair stories and history.

Roots
Kiana Davis

To understand
Your roots
You have to free yourself
From conditioning and programming
that says Black Hair is:
too ethnic,
too thick,
too nappy,
too unkempt,
and strip away layers of untruths
in order to live unmasked.

PREFACE

Dr. K. Mhina Entrantt

"Natural Hair is an Exquisite Crown. It's a wonder and fascination to many. But to the confident Black girl or Black woman who's rocking it, they know what they've been born and blessed with. A head full of unique, healthy, beauty. NATURAL BEAUTY." Stefanie Lahart.

Opening this book may take you deep into a world that you may not know about if you are not a descendent of the continent of Africa -the journey of Natural Black Hair. Since the first day the African woman's feet touched the soils of the "other lands," not their home, her hair texture, style, curl pattern, and length have been subjected to ridicule, blatant attacks, and negative verbal encounters.

Twenty Generations later, Natural Black Hair is still considered something to be suppressed, rejected, and tamed. The Hair Journey of those of us kissed by the sun has been emotional, political, social, rebellious, unacceptable, too-much, unsightly, and a host of other derogatory descriptions, according to mainstream standards of beauty. To say the least, it has been anything but "Just hair."

If you are African American, these poems and short stories will be like coming back home—very familiar to you. There will be

tears filled with memories, neighborhoods, family, social hurdles, laughter, and hopefully a coming of self.

This collection of writers spans from young children to Baby Boomers, each with an individual Hair Journey to tell. The voices do not ask for pity or social boosts, but solely to be heard. For in the hearing is the acknowledgment of another's experience. It is not validation, acceptance, or inclusion that we seek; it is the freedom of hair expressions our Ancestors had in the homeland! Kinky, knotty, braided, bald, cut into designs, and the like were given their due respect, honor, and dignity.

CHAPTER 1
EMBODIED CULTURE

Embodied Culture
Dr. Jean Harris

In 1998, Dr. Jean Harris wrote: "Crown and Glory on the Journey: Hair, Culture, and Self Construction Among African American Women" for her Doctor of Philology dissertation in the Department of Anthropology at the University of North Carolina at Chapel Hill. Dr. Jean Harris granted permission to share an excerpt from chapter two of her dissertation.

Dr. Jean's study examines the significance of African American cultural memories and social position impact on African American women's self-construction and hairstyle practices. Dr. Jean focuses on historical and literary sources to reflect on how African American cultural traditions impacted their self-construction and hair style expression.

Excerpt: Chapter II Embodied Culture

Evidence of the emphasis African ethnic groups placed on hairstyles exist in early travelers' observations. Fifteenth century Portuguese accounts of West African life describe intricate hairstyles. An early seventeenth century plate documents the variety of hairstyles encountered by Dutch explorer Pieter de Marees (White and White 1995). Howard (1971) records the observations of a ship's physician regarding the significance of hair styling and grooming during the Middle Passage. The doctor notes that slaves sat down in pairs for hours, grooming heads and "afterwards twisting and plaiting the wool in a variety of forms."

Stedman (1971:114) describes captives who disembarked a slave ship with 'their hair shaved in different figures of stars, half-moons, & etc. which they do by the help of a broken bottle."

Living in pre-literate societies, early Africans left evidence of the importance of hairstyles in their material culture. Two-thousand-year-old heads, with sculpted hairstyles were unearthed in Nigeria. A head dated from 550-750 AD was found in Egypt (Simkin 1982:11). African hair stylist Sagay's observation that "Africans rarely leave the hair or the body in their simple, natural state but spend a considerable amount of time and energy on grooming and adornment" (1983:ii) is as true for African descended peoples from earliest times in the Western hemisphere as for the more recent populations that she references.

The hair of African peoples is typically tightly coiled, highly elastic, and porous. These characteristics differentiate African hair from that of Europeans, Asians and indigenous populations in other parts of the world. The character of African hair has made possible a tradition of hairdressing that includes wrapping and braiding in styles that are impossible for Europeans.

Not surprisingly, hair texture later became a principal criterion in the racial classification system developed by physical anthropologists. Hair texture has been second only to skin color among physical characteristics used arbitrarily to construct social 'race" (Mercer 1987; Patterson 1982). So loaded has been the significance of the tightly curled, resilient texture of the hair of many sub-Saharan peoples that no less eminent anthropologist than St. Claire Drake 59 (1987) cryptically speculated that the course of relations between whites and blacks might have gone differently had Africans had wavy hair.

After arriving in the Western Hemisphere, enslaved Africans had scant time, tools, or opportunity for hair *grooming*. Nonetheless, care of their hair remained the responsibility of the slaves and became for them one of the few areas of their lives in which they exercised control. As they were able, African men and women adapted a variety of tools as substitutes for familiar grooming implements. Animal fat was substituted for the vegetable-based unguents of which the slaves had been deprived, and kerosene and turpentine were experimented with as cleaning agents. Physical differences between Africans and Europeans facilitated the maintenance of boundaries institutionalized by hereditary slavery and rationalized by scientific racism.

The presumption of slave status, blackness, and inferiority became so intertwined that the modifier, "free," was appended to identify blacks who were not enslaved. The rule of hypodescent that governed "race" relations resulted in a variety of phenotypes sharing inferior status because of membership in the category variously labeled, African, black or negro. Contrasting with other parts of the Western Hemisphere, in the United States a black person was one with 60 any known *or knowable* black ancestry regardless of appearance.

As free and enslaved blacks at times "passed" for white, white people devised methods to identify impostors. Hair texture was an important means by which to differentiate. The value of hair as racial marker is in part what is connoted by the adjectives "good," and "bad" attached to less or more African-textured hair. With the elaboration of a racist social system and the hegemony of European derived culture, hair texture and hairstyle assumed great political significance.

Control of the enslaved captives' bodies was the right of the master. Forcibly cutting the hair of slaves became a medium of "discipline" (Foucault 1978) exercised by slave masters (Foster 1997). Both men and women were subjected to having their hair cut against their will. However, as documented by comments to Federal Writer's Project interviewers, black women were more frequently disciplined by having their heads shaved or their hair cut (White and White 1995). It was not uncommon for wives of slave owners to shear the hair of female slaves in an attempt to render them less attractive to the masters or as a means to assert dominance. Yanking and shearing were also common forms of discipline used by slave masters. Harriet Jacobs' 1861 narrative offers a slave woman's view of shearing as a sexualized exercise of power. Jacobs recounts actions of her master, Dr. Flint, after she has spurned his advances:

(The doctor) "rushed from the house and returned with a pair of shears. I had a fine head of hair; and he often railed about my pride of arranging it nicely. He cut every hair close to my head, storming and swearing all the time." (Jacobs: 1988:118).

Jacobs comments on the twin oppressions of patriarchy and slavery, 'Slavery is terrible for men; but it is far more terrible for women. Superadded to the burden, common to all, they have wrongs, and sufferings, and mortifications peculiarly their own" (Jacobs 1988:119).

Nor was hair discipline absent in the North. Harriet Wilson's 1859 autobiographical novel, *Our Nig*, is set in New England. After Mrs. Bellmont shaves Frado's "glossy ringlets," James Bellmont arrives unexpectedly and greets Frado,

"Where are your curls, Fra?" asked Jack, after the usual salutation.

"Your mother cut them off."

"Thought you were getting handsome, did she. Same old story is it; knocks and bumps? Better times coming, never fear, Nig" (Wilson 1988:70).

Federal Work Project slave narratives document the reaction of a former slave, Susannah, who was so angered by having had her hair cut off by her former master that after freedom, she walked from "Ca'lina to Augusta to sue him." (Rawick 1972:347).

Apart from its significance in relations between the "races," hair practices were important among slaves themselves. Within the enslaved community, hairstyles had personal and group significance. White (1995:48) asserts that hair styling was "one of the few areas in which whites allowed blacks a relatively unhindered scope for cultural expression." Because hair care was time-consuming and laborious, well-groomed hair became a status symbol among the enslaved. Hair "pressing" with a flatiron designed to press clothes was practiced beginning in about 1820 by some urban blacks (Tyler 1990:235). Commonly, enslaved women wrapped their natural hair to stretch the tight coils and make the hair more amenable to styling.

After freedom, hair texture remained a mark of racial identity. Among whites, coily hair continued to signal black "blood." Blacks themselves exhibited no uniform attitude toward African textured hair. Mirroring the range of opinions on the separation-assimilation continuum, some black people advocated for wearing coily hair in its natural state as a badge of racial pride; others viewed African texture as an obstacle to acceptance by whites.

Assimilationist Booker T. Washington advocated middle-class Victorian conduct and beauty standards, including European hairstyles. However, a contempora*ry* of Washington, M. H. Freeman, in an article in the *Anglo-American* Magazine, railed against an evaluation that equates beauty with

The Anglo-Saxon standard (whereby] kinky hair must be subjected to a straightening process -- ailed and pulled, twisted up, tied down, sleeked over and pressed under, or cut off so short that it can>t curl, sometimes the natural hair is shaved off, and its place supplied by a straight wig, thus presenting the ludicrous anomaly of Indian hair over Negro features (Tyler 1990:238).

Bibliography

Harris, M. Jean.
"Crown and Glory on the Journey: Hair, Culture, AND SELF-CONSTRUCTION among African AMERICAN Women: Semantic Scholar." Undefined. 01 Jan. 1999. 56- 67

Foster, Helen Bradley
1997 New Raiments of Self: African American Clothing in the Antebellum South. Oxford: Berg.

Foucault, Michel.
1978 Discipline and Punish: the Birth of the Prison (tr. Alan Sherian). New York: Random House.

Jacobs, Harriet.
1988 (1861) Incident in the Life of a Slave Girl
Oxford: Oxford University Press

Mercer, Kobena
1987 "Black Hair/Style Politics." New Formation 3: 33-53.

Patterson, Orlando
1981 Slavery and Social Death: A Comparative Study. Cambridge, MA:
Harvard University Press.

Rawick, George
1972 The American Slave: A Composite Autobiography, volume 1, From
Sunup to Sundown: the Making of the Black Community. Westport, CT:
Greenwood

Simkin, Anna Atkins.
1982 The Functional and Symbolic Roles of Hair and Head Gear Among
Afro-American Women. Doctoral Dissertation, University of North
Carolina, Greensboro.

Stedman J. G
1971 Narrative of a Five year's Expedition Against the Revolted Negroes of
Surinam. Amherst: University of MA.

Tyler, Bruce M.
1990 'Black Hairstyles: Cultural and Socio-political Implications." Western
Journal of Black Studies, 14 (4) 234-247

White, Shane and Graham White

1995 'Slave Hair and African American Culture in the Eighteenth and
Nineteenth Centuries. The Journal of Southern History, 56 (1) 45-76

Wilson, Harriet E
1988 (1859) Our Nig; Or Sketches from the Life of a Free Black. New York:
Random House

CHAPTER 2
BLACK HAIR RITUALS

Hair- The Ritual:
The Black Woman's Untold Ordeal That Freed
Hair for Everyone (Excerpt)
Lois Watkins

I bit my bottom lip as I tightly pressed the top flap of my ear down protectively to avoid a direct burn. I winced as the intense heat from the smoking hot, heavy black steel straightening comb approached the side of my face to straighten my 'bad" hair.

Sometimes the beautician would blow her breath to cool the side of my face as she approached my hair with the hot comb, but it was futile: nothing could protect me from the intense heat of the hot comb, which had just been removed from direct contact with an open flame. Each time she removed the comb from the flame, she would wipe it on a piece of cotton cloth before combing it through my hair, which she had parted into thin sections, each requiring her careful attention with the comb. If the comb scorched or burned the cloth when she removed it, it was gauged too hot, hot enough to burn my hair. The problem was solved immediately by blowing on the hot comb and finalizing the ritual by giving it a hissing touch with her spit-moisturized finger, and she would continue artfully twirling tufts of my hair around her finger in preparation for the next onslaught.

I had to learn quickly, at an early age, how to hold my head "right," and to calmly allow the beautician to go through my hair with the hot comb, section by section. If I didn't hold my head right and got burned, it was my fault, never the beautician's. I'd

sometimes be admonished, "You gotta learn to hold your head right!"

It was a rite of passage for all little black girls in America to learn how to hold their head right, which included mastering two very important positions: how to hold the ear and bending over far enough so that the beautician had access to the fine hairs that grew from the back of the neck. Holding the ear with the opposing side of your head resting awkwardly on your shoulder allowed the beautician unhindered access to all of the hair growing behind the ear. If you didn't take care to protect your ear by holding it down, you risked getting it burned. The final torture came when you were asked to bow your head to the point of having your chin rest uncomfortably on your chest, exposing the vulnerable short hairs on your neck so they could be straightened, the area we euphemistically referred to as "the kitchen." When this occurred, you froze, not moving nor flinching. The very worst reaction was to obey the natural instinct to move away from the heat and anticipated pain to duck and dodge, even move a thirty-second of an inch. Any movement in this area, no matter how natural, invited a snap of pain from a quick burn. Bracing. The tension in the air became animate, all conversation ceased when the beautician got to this part of the hair-straightening ritual. Of all of the steps to having my hair straightened, having my kitchen straightened was the one most dreaded.

A popular term for getting your hair straightened was getting your hair "fried," and it was a true statement. As with frying anything, you must use oil and heat. The heat has to be hot enough to melt oil, as with frying food. Black women experienced the closest equivalent to having their hair fried when getting their hair

straightened. The oil, usually Royal Crown, Dixie Peach, or Hair Rep, was applied to the hair before adding the heat of the straightening comb, which resulted in a good shiny, hard press. Sometimes the hot melting oil from the intense heat of the straightening comb would sizzle as it made direct contact with my scalp, and it would burn.

The sign of having had a good "hard press" was when the hair was so straight and stiff from the cooled oil that one could easily see your scalp as your hair hung in long straight spikes around your shoulders. The next phase was curling. Sometimes my hair would be so hot from the pressing with the straightening comb and pulling with the curling iron that I would have to sit for a while to allow it to cool before it could be curled. Having my hair curled with the curling irons was far less traumatic. It was the fun part of the whole process because I got the chance to focus on style, and the curling iron did not get as close to my scalp as a straightening comb.

I don't recall ever getting burned by curling irons except for those occasions when I felt that an overzealous beautician determined the straightening comb didn't get my hair straight enough before the curling and would do what was known as getting one's hair "pulled." This required that she go over each part of my already straightened hair with a curling iron, section by section, pulling my hair from the scalp to the ends. Since I don't believe curling irons were originally designed for this purpose, the frequent close intimacy to my scalp almost always assured several burns.

Black women were labeled "tender-headed" if they had difficulty getting their hair straightened. They would duck, dodge,

and weave like a prize fighter at each wave of the hot comb. It didn't matter; there was no sympathy for the tender-headed black women. They were referred to with annoyance by beauticians, as it was unthinkable not to endure the process to keep the hair straightened. The tender-headed just had to get over it. The social pressure to maintain straightened hair far outweighed the pain associated with a visit to the local beautician. There were no exceptions. A black woman walking outside with her natural hair, even in the black community, would be shamed-- it was unthinkable.

No matter how straight our hair after this ritual, if it made contact with moisture of any kind, it went back to his natural state. Women who perspired through their scalps due to the close and intense heat had it worse because the heat of the iron would only exacerbate their condition, many times returning the hair to the original nappy state before the beautician could finish. The moisture from the sweating scalp sometimes created steam that burned the scalp as well. You risked a long-lasting sting if you attempted to straighten wet or moist hair."

<p align="center">*****</p>

One beautician stands out in my mind because my sister, Carolyn, and I would privately cry when we were scheduled for our beauty appointment with Mrs. Tyler. As little girls, we felt we had no choice. She never quite dried our hair before applying the burning hot straightening comb to it. She was a divorced single mother rearing a small son and was extremely nervous, totally oblivious to the torture she so carelessly inflicted on our young heads. Looking back, I think Mrs. Tyler needed the money to make ends meet and had just started a business without training or

skills. We were children in the third and fifth grades, and our mother sent us rather than took us to see Mrs. Tyler. We were about eight and nine years old. All we knew was that a visit with Mrs. Tyler, no matter how good her end result, represented torture to us.

We accepted the fact that we just had to go through it, we had to have our hair straightened, and this was a part of it. We could hear the hiss and see the smoke from the steam of our damp hair as we dug our nails into our palms with our small tightly gripped fists, enduring the pain of the steam burn, praying it would end, even though each time it seemed to take forever. Luckily, our visits to Mrs. Tyler didn't last long; our mother noticed several burn spots on our scalps shortly after a visit. We were overjoyed that we never had to go back to Mrs. Tyler again. We were too young to grasp the reality that before or after Mrs. Tyler, the process always remained the same, only a little more merciful. Regardless, black girls and black women shared the same experiences with straightening their hair--nothing changed when you got older. It was not at all uncommon to put a "warm" comb through a toddler's hair when she was beginning to show her first growth of natural black hair, thereby preparing her for a lifetime ritual. The expression would be, 'I think she's about ready for me to start running a warm comb through her hair."

Black people divided their hair into two broad categories, 'good" hair, and 'bad" hair. Black hair was considered good hair when it was, at worst, a tight wave, and, at best, straight. Natural black hair was classified as bad hair, and was considered nappy, frizzy, and kinky, difficult and sometimes painful to comb when dry, resulting in, at best, a puffy frizz if not straightened. We

considered our natural hair an embarrassment, shameful, and a sign of an unkempt black woman. Black women went to great lengths to hide our natural hair. This attitude about black women's natural hair was shared among black women as well as black men. We considered our hair one of our least desirable physical traits; it made us stand out as different in a negative way, still a "wild" African. Straightening our hair made us more presentable and acceptable, less offensive, or so we thought. We shunned our natural hair, believing that to wear it that way was unthinkable, although we weren't more accepted by whites because of it. Maintaining straightened hair at all costs for black women was one of our attempts to get as close as possible to the white standard of beauty, and we enjoyed attempting to imitate the hair styles of white women.

Black women's desire to appear presentable to the white culture resulted in a black woman becoming the first self-made female millionaire in America, Madam C. J. Walker. Her efforts, as she described them, were not to straighten black women's hair, but for black women to "...take greater pride in their personal appearance," and to give their hair "proper attention." By addressing the hair needs of newly freed black women, by 1911 she had built the largest black manufacturing company in the world, Madam C. J. Walker Manufacturing Company in Indiana. Her business not only increased black women's self-esteem by providing opportunities for employment, it expanded black women's economic opportunities as well--they had job opportunities beyond share cropping, washing clothes and working as domestics for whites. She was a philanthropist for black causes and by her death in 1919, she had over 15,000 employees.

Like black churches, the black beauty shop was one of the centers of cultural exchange of information between black women in the black community. Getting your hair done usually took at least half a day, and sometimes all day. We would sit for hours gossiping and sharing what we knew of the up-to-date news and the latest in style and music. Black women would congregate, en masse, lined against the wall in various stages of getting their hair "done." This was especially true on Saturdays, the busiest time. We were preparing for one of the most important events of the week in the black community, attending church on Sunday.

Black beauty shops ranged from sitting at someone's kitchen stove to a shop with a row of washing sinks and upright hair dryers, though there were few of the latter. A good beauty shop had the latest black magazines, Ebony, Jet, Sepia, and Bronze Thrills. We'd order from the local café and eat our meals at the beauty shop because the wait took so long to get our hair done, and we didn't want to miss our turn. As with black churches, one of the biggest complaints about black beauticians was getting out on time.

The torture I've been describing was a commonplace ritual for over one hundred years for all black women in America whose hair was naturally nappy or very tightly curled. We were most ashamed and embarrassed by our hair in its natural state. We went through torturous lengths to have our hair appear as close to a white woman's as possible, hiding who we really were.

Black women before the '60s and the Civil Rights Movement knew being beautiful began with straightened hair. All media, including all black magazines, depicted only black females with straight hair--it was our unquestioned standard of beauty. Our naturally nappy hair was something to be hidden and quickly

remedied. New growth, sometimes referred to as "edges," had to be quickly straightened when it occurred between appointments with your beautician. Every black woman's household had at least one straightening comb. It was okay to tell a friend, "Girl, you are going to have to do something about those edges...." It was accepted that your head would be sore for a few days after your hair had been straightened, and you had to be wary of your comb hooking onto a scab or two or three.

<p style="text-align:center">*****</p>

Although black women had been routinely straightening their hair since the late 19th century, earlier black women who worked in the master's house during slavery would sometimes have to "iron" their hair to look presentable. My direct experience with this was during the '40s, '50s, and early '60s in America, the era before "black is beautiful," and before the Afro hairstyles which represented the sudden change in attitudes and images of blacks as a result of the Civil Rights Movement. For the first time in America, it became okay to just be black. It was not only okay to be black, it became okay to show off your natural hair with pride. This resulted in the ubiquitous large Afros of the '60s. Young black women throughout the nation suddenly, in droves, began to display their natural hair for the first time without shame or embarrassment. Not only did we proudly display our natural hair, we wore it big, unmistakable, difficult to ignore--the bigger the Afro, the better. Black men did the same. We proudly called our natural hair "Afros" because our hair unmistakably displayed our African roots. We became united, presenting our true identity to America, not trying to be something other than what we were. We all knew we came from Africa--we didn't know where in Africa,

but our evidence was our hair and skin color. We couldn't change our skin color, we had done our best with our hair and then it became okay, and we owned ourselves. This was the first time in America that American standards of beauty included black women, and most importantly, blacks became more accepting of standards of beauty for ourselves.

The shame of our natural hair had affected generations of black females, who never learned to swim for fear of getting their hair wet, returning it to the dreaded and embarrassing natural state as soon as it made contact with any moisture, including light humidity. I don't believe that other races of women have any idea of the lengths that black women went to in order to straighten their hair, nor do they understand the significance of the impact of freedom resulting from the Civil Rights Movement on our hair. The '60's gave us permission to accept all of ourselves, liberating black women from pain and suppression of their hair. We had over one hundred years of having to constantly suppress a natural part of ourselves, hating it. We accepted this as part of what black women must go through in order to look presentable and be accepted. We hid our natural hair at all costs. Some black men, particularly entertainers, would straighten their hair, which was referred to as "conking." They used chemicals such as lye instead of the torture of the hot comb, but most black men wore their hair naturally. Black men had only to allow their hair to grow longer for an Afro; black women had to develop new techniques for managing their hair in order to wear an Afro. I never questioned why black men freely wore their hair naturally, and black women were shamed by their natural hair and felt they couldn't. For black

women, our hair was the only thing we could change to appear to fit in.

We started singing James Brown's song, 'Say It Loud, I'm Black and I'm Proud!' To other races this may have seemed overbearing, but to blacks, African-Americans, in over two hundred and fifty years in America, this was the first time in our history that it seemed okay to be black. We didn't feel less than anymore, and that whites were better than we were because of the way we looked. Black women stopped feeling the shame of their natural hair and showed their freedom and pride through their hair; we took it to heart. We allowed it to grow as large as possible, black women as well as men. The Afro started with young black women, and soon progressed to older black women who had at first criticized young black women for doing it.

The most positive outcome is that black women in America evolved to the place of personal choice. A lot of young black women today who have chosen to wear their hair naturally have no idea of what it was like to go through the full, old-fashioned, hair-straightening process. We now have a choice, and most importantly, all are accepted, and no one cares. This is also true for white men--they were safe to wear long hair and ponytails, and they became hair- liberated as well. The 1967 off-Broadway musical 'Hair" attests to the popular liberation through hair of the '60s.

Permission was granted by Lois Watkins' to share an excerpt of her memoir What *It Was Like...Short Stories of Childhood Memories of Segregation in America*. In her memoir, Lois shares a series of short stories describing childhood experiences in segregated Little Rock, Arkansas, during the 1940s and '50s.

What *It Was Like...Short Stories of Childhood Memories of Segregation in America* is available on Amazon.com.

CHAPTER 3
HAIR-ESTEEM

Hair-Esteem
Aisha Robinson

Currently, my hair is in between a press-out and puffiness. I washed it and pressed it a week ago with the intention of having a two-week hairstyle. I did everything right. I covered it when I went outside to protect it from rain drops. I was dancing really hard a few days after I pressed it. I ran outside to get some air to prevent my press out from being destroyed. I was horrified to find the front of my hair beginning to puff up. I promised to take the flat iron to those stubborn strands and 'press' it again, vigorously. That was over a week ago, and I could not get to it because I have two sons that are six and seven year olds, and they come before anything.

My hair story has changed over the years. My first experience with hair was having to sit down so my mother could comb my hair. She was never a braider per se. I got two straight-back plaits or one round one. I never liked to do it, and I still don't. I had a basic black girl. I could call it kinky, coily, 4c hair. These are nice new terms to replace language previously used to demean black women and our hair. They are very nice words, but they don't apply to me. My hair is thick and nappy, and if I could have had a wash-and-go hair, I would have chosen that. I still pray to the Lord to change my curl pattern. I'm too busy, and these kids get on my nerves, and I don't have time to do my hair, and I look messy most of the time, so I have to wrap it with a scarf.

When I was 13 years old, it seemed most of the girls were getting perms to straighten their hair. My mother really loved Bob

45

Marley and the Rastafarian ways, and I was enamored by their natural way of life. So as a young girl, I decided I would be natural for the rest of my life. I never succumbed to the pressure to straighten my hair, but I never wore my hair without braids. This was in the '90s in Belize, where I was born. Women wore braids or a perm.

As I entered my teenage years, I didn't anticipate I would change and how much my hair would become a part of my self-esteem. In order to attend high school, I moved from a primarily black area where I never stood out to a neighborhood and a school where dark-skinned and natural black hair was the minority. The change had a negative effect on my self-esteem. I was considered cute just the way I was at my old school, but at my new school, I felt the pressure to never show my natural hair. I lost my courage to freely be me. I wore my hair in extensions for four years.

After high school, I moved to America in the early 2000s. I became introduced to more African American culture. During this time, the natural hair movement was becoming more and more mainstream. I had more access to hair products and natural hair styles. I also encountered more young black men that preferred natural hair and were more conscious. It was an amazing experience to come across men with a higher understanding of the plight of black women in a society dominated by European standards of beauty. I became more empowered to be myself, love myself, and explore all the ways I can be beautiful in my natural state.

My hair story is less about my hair but more so about my self-esteem. I had to learn not to let anyone define what I would consider beautiful. I had to deprogram myself and purge myself of

the need to be accepted by anybody. After that, I was able to wear my hair. However, I wanted without a care in the world. I wore a weave, wig, braids, afro, etc. As long as I felt good and comfortable with myself.

Canvas

Unika Courtney Benedict

My hair is like a canvas
but not a blank slate.
So unique, so pure, yet still not free.
It winds,
it shrinks,
it curls
all so naturally.
My hair tells a story
so deep from within,
screaming to be seen
and heard
and not blended in.
Why must I change who I am to fit the script someone
made for beauty.
It's not just an ad,
Just a slogan nor a campaign
Self-esteem and dignity
shouldn't come on a cover
My hair should be free
and we should uplift each other.
Stand out

Be brave,

Be you,

And enjoy what was freely given to

you.

My Hair Symbolizes
Precious Manning

My hair symbolizes:
Beauty,
Strength,
Love,
Culture,
But some people want to take her
Snatch her like their vultures
Society has labeled her unprofessional
Nappy & crazy
Yet I laugh and explain she's a lady

You may call her exotic
But she's not the zoo
Not the circus
Or a freak show
So, choose your words wisely when you address
her and her flow
Just imagine
If I labeled your hair
Then you'll know what I felt

I don't feel those ways anymore
because my hair is stunning.
The way she flows in the wind like a big,
tall tree in a good breeze
Giving me radiance as if the sun sat right on my scalp.
That is what loving my hair and beauty is all about!
And remember those words when you try to touch my
crown.

Ms. Rochelle's Hair
LaKesha Kimbrough

Ms. Rochelle's hair is...
An entity with a mind all its own
An elegant and sacred covering
Ringlets, waves, spirals, and...
Pulled in a bun
Loosely hanging, flowing like gentle waves
French rolled
Plaited in four
Adorned, at one time, with wooden beads.
Using braids to tell an ancestral tale
Natural rings are singing a glorious song.
Telling and holding sacred narrative of past,
present, and future

Hair Free
Ranoda Wilkins

Hair free
When I was a little girl,
I used to wear plaits that went down my back
When I was a teenager,
I was too young to wear an afro
I always wanted to be free natural
Then I went through processes of perms and relaxing my
hair
oh, why did I have to go there
Finally free
No plaits, no perms
I can be Me!
Hair free.

Everything I'd Change
Mikka Bell

If I could change my hair, I would change everything.

If I could change my hair, I would change how it grows, from coily to straight, because since I was a young girl,

I've been told that I look much more beautiful with straight locs than I do when it's out and proud.

I don't feel beautiful in braids, or twists, or extensions.

When I wear my favorite hairstyle, the wash-n go,

I constantly get remarks from my family that I should go do something with my hair because it doesn't look good.

If I could change my hair, I would change its color.

Although my favorite color of clothing to wear is black,

I feel the opposite when it comes to my hair because all I see when I look in the mirror is the absence of light.

I recently dyed my hair brown to see if a change of color is what I needed, but it did nothing to my self-confidence.

I still feel ugly with my new brown locs.

If I could change my hair, I would also change nothing.

If I could change my hair, I would change nothing because

I know that changing my hair wouldn't solve the hate

I have just for being me.

If I could change my hair, I would change nothing because while I know my roots signify strength, and that it declares that it will not be silenced and that it has no problem standing up

for what matters, with shoulders back and its fist held up so high...I do.

If I could change my hair, I would change nothing because

I want to get to a place where I can see the crown on the top of my head, the strength and courage in my roots, love everything about myself from the color of my skin to the twists of my hair and declare that nothing needs to change because I'm black and beautiful just the way I am.

There is only one thing I'd change about my hair, and that is the way I feel about it.

My Roots
(This Ain't Another Poem About Black Pain™)
Taylor-Nicole Tinsley

This ain't another poem about Black Pain™
It's about My Kinky Coils
And Luscious Locs
The way My Hair shape shifts, twists, and bends
But never breaks
Resilient
Like My People
This ain't another poem about Black Pain™
It's about My Choice
A stream of straight strands
Washing down My Back
Or pillowy puffs
Placed on either side of My Head
Or braids
Tighter
Then Our coveted Culture
This ain't another poem about Black Pain™
Like My Coils
you think I shrink
when dampened

But My Thick Thatch is porous
Soaking up My Tears
Muffling My Cries
Silencing your hate
But wait!
This ain't another poem about Black Pain™
It's about My Roots
Greasy and glossy
Shea butter saturated Fragrant and free
My Roots
Burrowing deeper
My Roots
Swelling and spreading
No matter how many times you try to weed
My Roots
My Roots
My Roots
My Roots Germinate My Roots Cultivate
My Roots Proliferate My Roots Pullulate
My tresses Vegetate My People propagate.

Taylor-Nicole (She/They) is a Black Queer artist born and raised in Detroit, MI (Mississauga Territory), and currently residing in Seattle, WA (Duwamish Territory). They're a youth art educator, writer, and voice actor who strives to implement the art of play in everything they do.

Website: www.taylor-nicole.me

My Locs, My Garden
LaShonda Cooks

My locs are my garden. I bathe them in tea tree and peppermint. Water them with rosemary. And wrap them in bonnets, durags, and scarfs for protection.

At first, I didn't think I was worthy of them. Most of the other women I saw wearing them had a divine glow: a powerful sense of self that shone from within. They were unicorns. And I felt extraordinarily regular.

How do I get some of that magic, I wondered?

I cautiously read as much as I could and grew even more terrified. The history. The spirituality. The upkeep. The commitment. The dichotomy of love and hate they engendered.

Eventually, I succumbed, first in college. A sister from Ghana tried to start my locks the same way she did hers. But it didn't work. The second time I went to a shop in Mattapan, home to many Black immigrant communities in Boston. But it felt like a sweatshop.

Locs were mass-produced like candy and handed out without true connection or clarity. I took them down after a few months. My third try was the charm. I walked from my home to a loc shop up the street, frustrated at my own attempt to start them myself. The rest is history.

LaShonda Cooks is a Dallas-based artist and writer who loves exploring cultural norms, identity, and beauty through words and images. She received her BS from Babson College in 2010. www.shondasart.com

If I Can Change My Hair
Darcel Joseph

If I can change my hair, I'd change nothing... For my hair is simply an extension of my identity and who I was created to be. Every curl and twirl remind me that while this journey may not be easy, I was born to live freely.

Yet, sometimes, being born to live freely seems like a paradox. When at times I'm hated or mistreated for the crown I wear. It's as if my tresses ignite an instant fear. That's deep-seated in ignorance Mixed with a bit of unjustified arrogance.

If I can change my hair, I'd change nothing...

See, for many years, I lived by a set standard that said beauty was seen if my hair is straight and silky. But how could that narrative be a reality when it contradicts the uniquely diverse individual I was born to be? For you see, my swaying hips and lustrous curls Represent the merging of African and Indian heritages that produced a one-of-a-kind Caribbean beauty.

If I can change my hair, I'd change nothing...

Cause to change my hair means that I have subtly chosen to reject me... So, I'll say it again with flair;

If I can change my hair, I'd change nothing.

Darcel Stacy Ann Joseph was born in the twin island Republic of Trinidad and Tobago. Darcel is the Founder of a Non-Governmental Organization called Children of the Promise

Foundation and a Social Worker by profession. At the core of it, all she does is a desire to empower people to achieve their God-given potential. In her spare time, Darcel enjoys traveling, spending time with loved ones, and writing poetry. In 2020, she published her first eBook As I Evolve, a Poetry collection available on Amazon.

First Hair Lesson
Jelia Farr

My hair is a gift given to me by my ancestors.
My first hair lesson taught me that change
It is sometimes uncomfortable,
But you'll have a lot of self-love and understanding.
I believe the different kinks
and curls on my head make my hair good.
A good hair day is when my curls are poppin.
A bad hair day is when my bonnet falls off
while I'm asleep.
Good hair means healthy hair.
My hair is Good Hair.

Damaged Hair
Adria McGhee

Hair oh hair, what happened to you,

you're not the same anymore.

You were naturally curly, but I needed you straight.

Relaxed and straightened was my favorite style.

I liked the way you bounced after a fresh trim.

I loved the confidence you gave me.

What's your problem now?

Was it the years of relaxers and heat that made you thinner and brittle?

I haven't relaxed you in almost two years.

Now you're back to your natural state.

Yet, you're still damaged and now hard to manage.

So many hair products, trying to find the right combination trying to keep you healthy and moisturized.

I'm not as confident as I use to be,

wearing weaves and wigs just to give you time.

It's like you were telling me you needed a break.

Constantly recombing the same section,

I was just in,

Your curls are tangled again and again.

The frustration I feel wanting you to act right.

I just wanted you to look your best.

Hair, whether curly or straight

I will restore you, and you'll restore me.

YOU ARE BEAUTIFUL.

Embracing Her Hair—Embracing Herself
London Holmes

Close your eyes and imagine the most beautiful girl standing on the beach observing the sunset.

What does she look like to you?

Does she have a beautiful smile? What color are her eyes? Is her hair flowing in the wind? I cannot tell you exactly what you have imagined in your mind, but I'm certain about one feature about her. She has either straight or wavy hair. I imagine only a very small percent of listeners imagined a girl with thick curly hair.

Why is this, and what does this have to do with anything? Growing up in a world that values Eurocentric features, it was hard for me to feel comfortable with aspects of myself, particularly with my hair. This part of me did not fit in the category of beauty in America. There are common stereotypes about the hair of black girls that haunt our mindsets about ourselves. Subtle comments made by people that it is nappy, hard to manage, and undesirable.

Hearing comments like these diminished my self-confidence, and I felt the need to straighten my hair, especially during my high school years. Coils or curly hair has been seen as an undesirable feature is implanted in almost all aspects of this society. A simple search on Google images of unprofessional hairstyles and the results are beautiful black women with many

types of hairstyles, including buns, braids, and naturally curly hair.

What about our natural hair is unprofessional? Why should we have to conform to the universal views of beauty to be considered for a job or fit into a school, even in entertainment? It is common to see in movies, magazine campaigns, and TV shows where young women were only seen as desirable after their hair was straightened.

Young black girls, including myself, are often indoctrinated with the idea that we are beautiful when our hair matches with our friends that have straight or wavy hair. Despite the parents of black girls telling us our hair is beautiful the way it is. The social standards of beauty were set outside of our gates.

So, when did things change for me? I was influenced through social media by girls who had similar hair textures as me. It was my first-time seeing girls with the same type of hair with a positive outlook with so many people supporting it in the comments section on outlets like Instagram or Tick Tock.

I felt inclined to give my natural curls a chance during my senior year of high school. Many people would not think wearing your natural hair down is a big deal; for me, it was everything; it was terrifying. I was nervous I would face judgment through stares and comments or go through the typical experience of people uninvitingly petting my hair or making odd comments. Fortunately, I was faced with smiles and compliments, and I began to wear my hair down and felt supported by my friends and family.

Now I love my curls and would not change them for the world. They make me who I am, and I am grateful to myself

that I was bold enough and took steps towards self-love to my hair. On this road to accepting this part of myself, I have learned that I truly appreciate my hair for all that it is. Beauty is not subject to one certain look but in a diversity of styles and looks that humans have, and it is important to embrace and appreciate these differences. I know that there are so many girls who feel uncomfortable with their hair now.

So, when I think about wearing my hair down, I not only wear it for myself but for all the girls who feel that their hair is not beautiful.

London Holmes Accomplishments:

London Holmes is the founder of Fearless Aviators. www.fearlessaviators.com

London graduated from the United States Air Force Academy Prep School and started school in the United States Air Force Academy in June 2021.

Licensed Private Pilot

Alaska Airlines Scholarship

Women In Aviation Scholarship

PNBAA Grant Scholarship

LeRoy Homer Scholarship

AOPA scholarship

Tuskegee Airmen National Youth Academy Scholarship

Black Pilots of America Flight Academy Scholarship

National Honors Society

National Academy of Future Scientist & Technologist Award of Excellence

Interviewed by NBC Nightly News

Inducted into the Society of Torch & Laurel

Recognized by Alaska Airlines as a Junior Achievers

International Day of The Girl Honor

Member of the 2017 Legion of Youth Award powered by Boeing/Seahawks.

Featured in newsletters, PNBAA, Galvin Flying, LeRoy Homer Foundation, AOPA, Cascade Warbird, and MRO Congratulatory letter Governor Jay Inslee for leadership in STEM

Me Rocking My Hair
Vickie Thomas White

you can sometimes skip rocks on the water
without going too deep
that's what I'm gonna do
skip a few rocks over the water
of my hair journey

one rock
i was just turnin four when i heard papa say
'Momma, don't let that girl chile outta the house
with hair lookin like that'
i tried to look beyond my eyebrows
but I could not see
i did not know what he meant
i only know that my hair felt
free, airy in the warm sun
while i was swinging on the tire
and that papa did not like my free hair
that needed to be platted up
momma efforts began,
working on my head
comparin' my hair to her hair,

70

that's not smooth like my sister's hair
no. my hair is thick like
steel wool
nappy
hard
tough
tender headed . . .
takes a lot of work
my hair, the way it is was
not 'good' enough

two rock
i liked the pressin' comb
because it meant I would spend the night
at grandma's house on Friday
stay up late watching NBC
blue grease and hot combs
two pillows to sit on
next to the stove while grandma sat
saying 'cover your ear with the top'
while the grease sizzled
'So that I can get the edges'
made my hair smooth and
I could wake up in the morning
brushing down the smell of burnt hair

to cartoons until Noon, then watch Soul Train
and the comb'n and brushin'
did not get stuck
did not hurt my head
I stared into grandma's vanity and
pretended to be Pocahontas
she lasted for about 2 weeks
then the sprouts started out again
roots so strong that humidity or sweat
turned all that pressin into
rising puffy clouds of cottony complex landscape
all the brushing and combing
did not stop
my fingers from getting stuck in my 'kitchen'
by week 4
it was back to grandmas on a Friday night

three rock
i got a job i could make my own money
first thing i'm going to do is
get myself a 'relaxer'
mama refused to pay for a perm
saying pressin is good enough
but I can't be at the party
walkin IN with a mushroom or flip-style

and sneaking out looking like Hair Bear
that's gotta stop
besides boys, check out the girls with the hair
down to their shoulder
frustrating that my new growth is so strong
two textures on one head
a salon style that only lasts
one week
whatever the stylist had, I had
shampoo, conditioner, hemps, shine, serum
tried every tool
hairdryer, blow dryers,
i bought every product
pressing combs, curling irons, plug-ins
magnetic, sponge, perm rods, and rollers
style magazines, books
a bureau full of items
my personal beauty supplies

four (rock)..
then I learned that my natural hair
did not need alcohol or creamy crack
loved watering and to be left alone
two strand twists, French braids
silk scarves, turbans

each month I cut just a bit more
of the processed 'strung out' perm
until one day
a small, puffy cloud emerged
soft as cotton
staring back at me in the mirror, saying
'Hello, you, there You are
I been waiting for You
missing You . . . '
she waited until I passed through
all those impressions that others
had made on my mind and
on my self-perception and
I looked for God's signs in creation
that was more than enough
to define my beauty
beyond the cotton and clouds
finding likeness in dandelions' puffs,
lamb's wool,
girl, even in broccoli
textures so rich and strong that
did not have to apologize for not
being corn silk
keep rockin' your hair
keep rocking You.

My Lovely Hair
Tammy Debella

I love you, my hair
You are so fun!
So thick like fur
My hair I got from my parents
So much hair
So, I have fun?
Sure, I do!
Mommy's fine
Daddy's a bit kinky
Mine not quite so sure
 Almost a new breed
Unidentified for the record
Hanging in the middle
You can't name it this or that
They classify hair
with 1,2,3,4 and a, b, c
like the size of a bra
My hair is brown
On my crown
Back in the day
so much relaxer

like *Ethiopian Hair Butter,*
And so much heat to be smothered
It is so bold, never tired!
Never scared!
'Bring it on.'
It is so tough!
Don't you got more
Cooking oils or spices?
I don't mind the products
Get along, my chemists
Please get some good products
When I like the products,
They disappear from the stores
I got to find some new ones
over and over every time
All the time
So various and numerous
It takes me time in the aisles
But why my chemists?
Keep alive the good products
Make up your mind, I did
Make me happy; you could.
You got power
I love my hair; it is unique,
Or so for me every morning

Not when it got a roller set oblique

Fully set to unrest

No matter what

so important it is, as it is

I can't go bald just like that

I love you, my hair!

you are so me

you are so mine

you are so fine

Always my hero

Wig OH NO, NO!

So comfy as a pillow

Down to earth and low

Fearfully and wonderfully

Made all the way beautifully

Candidly altogether lovely!

Created so specially!

La la la lal all in all!

***Ethiopian Hair Butter History:**

Many Ethiopians use butter on their hair. It started as a wedding tradition. It serves as a way to protect their scalp from the sun, and it keeps their afros and dreadlocks in place. Many Ethiopians see it as a blessing.

I Thought I Would Say Don't Touch My Hair
Anonymous

Finally, the Faculty and Staff of Color conference was over. Even though the conference was a huge success and gave me life, I couldn't wait to go home and soak my feet. I gathered my suitcase and other items from the hotel room quickly, as I knew there would be a traffic jam trying to check out of the hotel. I failed to mention that I was in Spokane, Washington, in the Historic Davenport Hotel. The ding of the elevator made me smile, and I also felt good because the elevator was empty except for a middle-aged white woman.

I was expecting a crowd of conference attendees, also rushing to check out. I spoke to the lady in the elevator, and she spoke back. She said to me that she liked my hair, and I told her thank you. She then asked if she could touch it; I found myself leaning over and allowing her to touch my hair. I got off the elevator and asked myself, did I really just let that lady touch my hair? I have heard stories of this happening; however, I thought I would never let it happen to me! I always thought if it happened to me, I would say something witty such as, if I can touch yours first, or my beautician wouldn't like that. On my way to the airport, I kept thinking about what I had done; I felt I had let my black sisters down.

It bothered me so much. I discussed it with some black colleagues that were waiting to board the same plane. They were very surprised that I had allowed that. I knew they would be. I think, I told on myself, as a form of a punishment for what I had allowed.

That Hair

Aisha Roberson

Dear Black Woman
Did you know that hair
That hair that wants to praise the heavens
It is full of life
Transmitting Electric rhythms
through natural beings
Communicating to The Rock
That is higher than I
Daily
Cradling your strength and resilience
Well...
That Hair,
wants to spring up, not relax
wants to manage you
not be managed
wants to make them love you
That Hair,
has something to say;
"You are more than a woman."
The loins from which humanity came
from through which it shall return

That Hair,
Holds secret messages
Ready to be transmitted
and regurgitated
over and over and over
until the truth is received
For your infinite preservation

Unblocking the paths to your electromagnetic fields
that Hair will free your mind

will protect your soul
will soothe your pain
That Hair,
No one can harm it, but you
No one can disarm it, but you
No one can free it, but you
No one can rock it, but you.

Don't Touch My Hair
To'shar-ree Kelly

Don't touch my hair!
You can watch me with amazement
and give me a compliment from the heart.
Just don't touch my hair,
or this pit bull in a skirt will bark.
Sometimes my hair may be curly
and wet or kinky and dry.
But when I walk past you don't touch my hair,
just simply say hi.
You may see my hair in an afro
or sometimes I wear twists.
I don't care how much you adore my hair,
if you touch it
I'm gonna be pissed!
My hair is my crown,
and it will cause you to stare.
That's cool with me,
just don't touch my hair, and I mean that!

To'Shar-ree Kelly resides in Michigan City, Indiana, with her beautiful daughter Malaicah. They also can reach me at blackgold914@gmail.com.

CHAPTER 4
SEATTLE NATURALS

What I Asked For vs. What I Got
By Adrien Paine

What I asked for was a bob. After years of the same basic style (silky wrap with a side part that spent most of its time in a basic mom-bun, *yawn*) I decided I wanted something different. What I got?: The same basic silk wrap with a side part that ended up in a basic mom-bun. Again.

So, then I asked for tips on "how to go natural". What I got was a whole new cyber world that gave me access to forums full of information and kinship with Black people around the world on the same journey as me.

What I asked for was tips on how to transition because *gasp* I couldn't fathom myself with short hair. God forbid!

What I got was a Big Chop. A euro fade, to be exact. Less than three months after I started this "natural hair thang," I couldn't WAIT to free the little waves growing near my scalp! I went to Earl's Cuts & Styles on a January morning and got an experience that transformed me from the moment I swiveled around to look at myself in the mirror. For the first time, I had short hair and a whole new vibe.

Immediately I went to my friends and family and asked "Do you like it?! What do you think?! "What I got was a few blank stares and nervous smiles at first—concerns for my mental well-being and covert inquiries into my sexuality. But I also got looks of surprise and delight, encouragement, tips on how to style my

new little baby fro, and a somewhat urgent girl's trip to get my eyebrows done to pull my new look together.

As my Afro grew and progressed, so did my journey. I dove in with all my questions about styling techniques and product recommendations. What I got: was WAY too much information full of acronyms, alphanumeric hair typing systems, 14-letter ingredients couldn't pronounce; scientific explanations of said ingredients; and various psycho-political-spiritual breakdowns of what it means to be Natural, which would have overwhelmed me if not for the patience and generosity of my newly found Natural Hair Community (aka BLACK WOMEN).

I clicked and scrolled through this new online community, never having an inkling of how deep and impactful it all really was. It unlocked a door in me that I didn't realize was even there, waiting to be rediscovered. I longed for and even envied those places like Philly and Atlanta where natural hair thrived, and Black people gathered, effortlessly and often, to

bond over all things hair and CULTURE. And wondered, "Why not Seattle?"

For those of us who grew up in the PNW, most of our objective as Black people was to blend in, assimilate. We exist in a community of covert racism that rewards Black ambiguity with performative acceptance. A place that boasts "I don't see color!" while forcing you to code-switch to survive and mute your Blackness for their comfort. These are things I just didn't SEE until my Afro pushed my introverted Blackness out onto the center stage. I was hooked.

So, one day, I asked for a few friends and family to join my lil natural hair group. I figured we could meet up to sip wine whilst

twisting each other's hair and doing product swaps on occasion...
I raised the roof when Seattle Naturals reached 20 new members.
I was elated when we got to 100 members and had our first meetup
in Renton. I had new friends! Beautiful smiling Black women with
different curl patterns, skin tones, and stories about their
individual natural hair journeys. And I thought, "Yay, I did it!"
And I was content with my lil tight-knit Seattle Naturals family...

But Most High had other plans!

What I asked for was Curl-friends. What I got was a whole
community of sister-friends that greet me with smiles and hugs
and affirmations when they see

me out and about. What I got was a plethora of mentors and
"aunties" that put their hands in my hair and spoke life and
encouragement into my spirit.

What I asked for was a haircut. What I got was the opportunity
to share moments with my Son while we both sat in the barber's
chair, basking in the laughter and wisdom of Black men.

What I asked for was an occasional meet and greet. What I got:
was a schedule full of events where I could witness Black
Excellence in the form of stylists, artists, writers, musicians,
activists, community organizers, chefs, creatives, and educators.

What I asked for was socially acceptable, well-behaved, and
defined curls that made me look "cute". What I got was the
responsibility of showing up BLACK everywhere I went without
the filter relaxers afforded me. My kinky texture demanded
respect, took up space, and forced me to use my voice even when I
just wanted to blend in and be quiet. It made me confront the
politics of being Black in predominantly white spaces, and it
showed me why Blackness is worthy of being centered, protected,

and cherished. It challenged my social anxiety and quite frankly grew me up.

What I asked for simply wasn't big enough to hold the blessing God and the ancestors had in store for me. I started this journey wanting a new style. And it led me to the community. Self-discovery. Renewed Black esteem. Business opportunities. Relationships.

Knowledge of self. History. And a platform to encourage and lift others along their journey.

What I asked for was a "Big Afro." What I got was a connection that generations of war against our Black bodies and spirits cannot ever fully sever even way up in this little corner known as the Pacific Northwest. Through this natural hair journey, we find a way back to each other, to the glory of Blackness. Always.

Oh. And I also got my Big Afro.

Adrien Paine, Founder of Seattle Naturals

Seattle Naturals is a place to share hair tips, ideas, products, pictures, ask questions, motivate, and network within the natural hair community in Seattle.

Wearing It Bolder
Valerie Howard

As my mother would wash my hair

and give it care, it hurt

To where I would dig my chin under my shirt

I was wondering: if there was anything that would work

Because my hair hurt

My kinks and coils were like most

but to me, my hair was a joke

Not because it had coils and kink

But it was nappy with no slink

At least that's what others had me think

Didn't lay on my shoulders

Not wearing it bolder until I got older

No more digging my chin in my shirt

But still, it hurts and I'm older

Due to the World being colder

But I will still wear it BOLDER.

Hair Tools and The Journey
Carla Banks

There were so many tools
to wrestle my hair into submission
Only to have HER return,
A WARRIOR, in a fighting position
She was never loved
in her Natural state
Tortured and persecuted
To make her lay down straight
Sticks and bands, rollers, braids, and cuffs
they were no match for HER Fierce coiled puffs
Combs and brushes had Her looking presentable
barrettes made her look so gentle and girly
by the end of the day, her natural was back
BLACK and ever so "excessively curly"
Hot combs were handed down
and heated on the stove
only after a wash and
blow-dry to get it partially straight
but the heat of that metal comb,
nothing could resist its teeth,
its oppression, its weight

Relaxers did a number on her
caused her burns and stress
Jheri curls left stains
All kinds of greasy mess
Summers were great
until it came to the pool or the beach
I had to have my hair braided ahead of time
hoping there was a conditioner
and stylist within reach
Hands and knees detained my body
while braids hogtied her to my tender head
then at night a scarf, silk bonnet
maybe even rollers acompanied her to bed
Picture day at school was always a disaster
No matter what was done to my hair
by the time it was HER turn
She looked like black licorice-flavored,
cotton candy after the fair.

To Sweat Out This Flat Iron or Not
Leilani Farr

To sweat out this flat iron
or not to sweat out this flat iron
That is the question
Those Burpees, Star jumps, Oblique twists
all have my name on the
There is just one thing that is stopping me from being Great:
My hair
Do not get me wrong
I would not trade my crown of coils for anything.
But this flat iron has my coils living their best life via shakable bouncy waves that can be tossed over my shoulder with the greatest of ease.
So, the words keep rolling around in my head.
To sweat out this flat iron or not to sweat out this flat iron.
I could have had some cute little box braids or Micro singles with golden honey highlights, but no,
I wanted to feel the swish of my hair along my neckline.
The cute way I can sweep it behind my ear when I'm concentrating or throw my baseball cap on and head out the door.

I also want to do some Cardio kickboxing, or maybe some Barre HIIT with a little 30-minute Yoga flow at the end, but guess what I have to consider first????

Well, I have decided this fitness journey that I am on is so much more than having to stress about these tresses.

I am going to embark upon some protective styles and get this good Trap Cardio in, and who knows what else. So, sweat, I am ready for you.

Leilani Farr is a Fitness instructor in the Seattle area.

The Most Beautiful Little Black Girl in The World.
How the book Cornrows by Camille-Yarbrough - Illustrated by
Carole Byrd, helped influence the unapologetically ambitious
black women I came to be.

Courtney D. Clark, M.A. E.D.

College Park, GA. (1979-1980), I was four years old going on five when my Mother and Father (Denise and Louis Clark) brought the book *Cornrows* into our home. I was infatuated with the book cover alone! The book was originally gifted to my family by a cousin (Niyonu) who was an active member of the Shrine of the Black Madonna in Atlanta, Ga. The shrine had a book fair that was promoting the book, and she bought one for me. The book sat on our bookshelf for many, many years. It was my most favorite book to hear read to me by my mother. I saw myself in the illustrations, and the book made me feel like the most beautiful little black girl in the world!

My mother and father, both generational natives of Atlanta, Ga, were very well-known socialites, Black church members, purveyors of musical arts, and Black culture in the Black community. Both had great pride in being Black, educated, and successful. They understood the importance of instilling that same pride in their children.

I was born to a radiantly beautiful 21-year-old vibrant, thriving, and urban red-haired afro-wearing mother. She was the most beautiful woman in the world to me and was my best friend early on in our mother-daughter relationship. My

mother wore ornate and diverse natural hairstyles-afros, braids, and blowouts- Owning Each Look! She passed that self-love, that hand-me-down love right on to me by grooming my hair and teaching me her Black girl hair magic.

The storybook cornrows followed me everywhere. My Uncle Edgar's girlfriend at that time was one of the first manifestations of black excellence and mesmerizing beauty. She was a beautiful dark-skinned, thick-lipped, full natural afro hair-wearing woman who truly mirrored me. I can pinpoint the exact moment when my life opened up to her, and it was at my grandmother's house, sitting between her thighs as she braided my hair into the most beautiful cornrow designs. She had created a majestic crown of cornrows with wooden and jeweled toned beads, while she told her story of Black pride, a soon-to-be Spellman College graduate (a Spelmanite), with a desire to change the narrative of how fashion sees black people; all of that power and wisdom was intricately weaved into each strand of my hair that she braided. I stared at myself in the mirror, admiring my new braids, and I saw boldness- Dazzling Authenticity! I'm not ashamed to say that I judged every girlfriend my uncle dated after the Spelmanite based on how well they braided my hair.

In the summers, I loved visiting my Great-Grandmomma Alabama (Stella), in Luverne, Alabama. I was engulfed by the swapping of laughter and the best family stories! Oh! And that good tea! Listening to your mother, grandmother, great-grandmother, and aunties gossiping is A Different kind of Tea! My young cousins and I would watch, listen, and learn as my Mother would trim my Great-Grandmommas ends and braid

her long thick healthy silver-gray hair while my elders told family stories. As a family, we groomed each other! I come from a long lineage of ancestors who took great pride in the appearance of their hair. In our communities, to be well-groomed meant that you were loved. I was loved, and I felt intimately cared for and connected.

My family understood the world and that a dark-skinned little girl wearing natural hair was not seen as conventionally beautiful in the World. They knew the barriers of being black in America, in all the ways explicit and covert, that someone with my hair, my lips, and dark skin was told she isn't enough. My parents made the audacious decision to leave the comfort of the Black community and move north of the city of Atlanta to Roswell, Ga, during my 3rd-grade year of elementary school. I was the only Black child in my neighborhood and at the time 1 of 5 African American students in the school. I held the book *Cornrows* so close to my heart as I transitioned from being surrounded by prominently Black and brown thriving communities and schools to drowning in whiteness. The book *Cornrows* were one of many lifelines during my journey toward embracing my identity and finding my Black Girl Magic. These foundations supported my courage to be authentically me.

My Uncle Edgar's girlfriend at that time was one of the first manifestations of black excellence and mesmerizing beauty. She was a beautiful dark-skinned, thick-lipped, full natural afro hair-wearing woman who truly mirrored me. I can pinpoint the exact moment when my life opened up to her, and it was at my grandmother's house, sitting between her thighs as she braided my hair into the most beautiful cornrow designs. She

had created a majestic crown of cornrows with wooden and jeweled toned beads, while she told her story of Black pride, a soon-to-be Spellman College graduate (a Spelmanite), with a desire to change the narrative of how fashion sees black people; all of that power and wisdom was intricately weaved into each strand of my hair that she braided. I stared at myself in the mirror admiring my new braids, and I saw boldness- Dazzling Authenticity! I'm not ashamed to say that I judged every girlfriend my uncle dated after the Spelmanite based on how well they braided my hair.

Black women are expected to water down our complexity, and our natural beauty is seldom allowed exposure in the narratives written for us. Little Black girls have grown up in a world that has constantly told them they are ugly. The book *Cornrows* was a tool of enrichment for my parents that taught me how to combat the stereotypes and negative assumptions deeply rooted in Eurocentric beauty standards that value whiteness by loving myself. My parents set an unwavering foundation of spirituality, self-love, and worth within me.

It begins with our crowns-understanding the power of owning our natural hair, knowing our family linage, and family stories of courage, honor, resilience, wisdom, love, and strength. That generational hand-me-down culivated love.

Courtney D. Clark has built her career performing on stage and teaching music in the classroom. Since joining Seattle Opera as School Programs Manager she has led the curriculum, development, and growth of opera and multi-arts learning programs for students and teachers across Washington State.

As an opera singer, Courtney has performed in concerts and solo performances in the U.S. and abroad and as a tenured Nashville opera chorus member. A native of Atlanta, Georgia, she holds a B.A. in music from Morris Brown College and an M.A. in Music with a specialization in vocal performance from Middle Tennessee State University. Courtney obtained her teacher licensure and certification from Belmont University for the states of Tennessee, Georgia, and recently Washington State for K-12 vocal/general music education, and holds Orff-Schulwerk Level I & II Certification to teach children music.

Courtney is passionate about this work. She brings dedication and intentionality to create racial equity in arts education as she continues to strive to create a more socially just world through the lens of music and the practice of diversity, equity, and inclusion.

You're Not Black
KaSheen B. Brown

"You're not Black!
If so, why is your hair so curly like that?"
Having to explain the roots
Coming from my scalp, all the while showing
what my blackness is about!
I love my hair!
I love every curl!
I even love how humidity takes over.
Blessing me with a mighty fro!
My beautiful hair is a statement of who I am.
Do not touch!
I am the clutch of African, Creole, and Indian culture!
So, to answer all the questions about my coiled crop
I say hell yea!
I am a Queen, Black, and Proud!

Reclaim

Kiana Davis

To reclaim
what was lost
you must learn
to reconnect
with apart of
yourself
that you were
taught from
birth
to hide
and burn
to oblivion.

CHAPTER 5
YOUNG VOICES

Good Hair
Heaven Lee Age 11

Good hair is unique.
Bad hair is messy.
My hair is on point, meaning cute
Meaning nice and unique
My hair is not crazy.
My hair is fly as the wind,
Soft like a palm tree,
And colorful like my skin.
When it comes to my hair,
You have to be careful because I am tender-headed.

I Like my Hair
Jannah Lee Age 7

I am in first grade.
I love being in first grade.
A list of how I like my hair:
I like my hair.
It is soft and beautiful
And it's in locs
And it's powerful the way it is
And my brown skin is different from my hair.
It's powerful the way it is
It's not cranky
it's beautiful.
I do not want to change my hair or my skin.

Hair Journey
Cortney Walker Age 16

My natural hair journey is definitely a long one.
From insecurities to "unprofessional, unkempt" to not fitting
beauty standards are not far distant from each other.
In elementary school, watching all the girls with their
straight hair.
"Why does nobody have hair like me?" Blonde girls with
blue eyes get all the attention. Going into middle thinking, am
I worth it? Maybe if I take these braids down.
Don't you dare use nappy as a derogatory term with me;
it's just not combed out.
Wakanda hair? Are you serious? 7th grade,
maybe I should get a perm.
I straightened my hair today just to get asked
if it was my real hair.
I can't win with this natural hair thing.
I thought light skin women had 3b hair,
or is it just the biracial?
Have you ever got clowned in the middle of class
for wearing a fro?
Then you don't understand my struggle and frustration.
Still in high school wondering why my box braids are
deemed ghetto, but when my Asian classmate gets them, she's
praised.

They aren't even for her hair type.
Why when I have shrinkage, you call me bald,
but when I retain length, you say
I'M WEARING A WEAVE?
I know what I have is beautiful
but why don't you?

3b and 3c Hair
LaNiya Dixon Age 16

3b or 3c somewhere in between

Scared to wear it out because it is not the length I wish to proceed.

So, I hide it with weaves.

Too thick when dry too short when wet

the shrinkage be real

All these extra products

I need for my hair as a black girl

If I were a different race, it would be way easier just water or hairspray.

Been protected by weaves and braids, my natural hair is not even a thought.

Have u ever felt insecure about wearing it out in a little afro?

Have u ever got frustrated because the rubber bands kept popping and breaking?

Well, that is my struggle.

Black Hair Rules
Rose Bolamba Strasbaugh Age 7

I am brave

Who I am

Me

Ancestors

Box braids

I can wear it in an Afro.

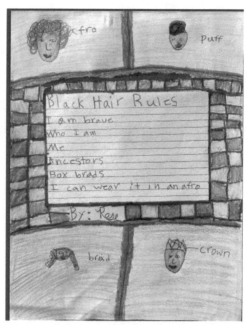

Artwork by Rose Bolamba Strasbaugh

My Hair
Atara Wilcox Age 14

My hair is a part of me.
One of my struggles
and one of my accomplishments.
Thick but manageable
My hair is my own
and nobody else's
My hair growing
in its own way and beauty.
My hair is kinky, soft, and poofy.
I don't like the way my hair doesn't curl enough
that it's not long enough. The texture of my hair teaches me
that I have to detangle it. My cousins constantly compare
our hair, rating mine as the best,
but I think my hair is too soft
and when I lay on it,
it turns flat.
When my hair decides to cooperate,
I have a good hair day.
A bad hair day is when my hair is too kinky,
and it hurts to detangle it.
My hair is soft but kinky.

Touching My Hair
Taila Wilson Age 11

Hi, my name is Talia Wilson, and this is one of my many hair stories. This one is probably the best one I can remember in detail. My hair is important to me because there are so many things you can do to it, like twist it, braid it, or let it be free. At school, I do not ever feel comfortable with my hair being free.

One afternoon, while I was packing my stuff up, one of my classmates came up to me and touched my hair. I was not really surprised about this since my hair was in a ponytail. Since it was sunny that day and I have curly hair, my hair was very puffy, soft, and big. When he did this, I asked him to stop in like a joking way, not too serious. He went back to packing up his stuff. Five minutes later, when I was in line waiting for the bell to ring, I felt fingers touching my hair again. I looked behind me and saw it was the same kid acting like he did not do it.

I was starting to get annoyed, but I did not say anything because I didn't have proof; he did it, so I just turned back around. Once I turned around, the same fingers were touching my hair again. Now I was a little mad. I turned around again and saw the same kid was touching it when I said to stop. This time I was serious. I said, "PLEASE STOP."

Finally, the bell rang. I went out of the classroom saying my goodbyes to my teacher and friends when I feel more fingers touching my hair. I saw that more kids were touching my hair. "Great, now everyone's touching my hair," I said really quietly.

When they saw me notice them, they ran off laughing. I was mad! I think everyone saw them touch my hair, so now everyone was doing it. I was kind of embarrassed.

I was speed walking to my school bus stop. When I finally got there, I sat down in my seat, waiting for other kids to get on. When everyone was finally on, and I was talking to my friends... again, more fingers. I turned my head as fasts as I could, and I saw two of my classmates were touching my hair.

When I saw this, I said in my head. "Ok! I'm done with this," so I turned around to face them. In all seriousness and anger, I told them to stop.

They finally stopped. This was not the first time this has happened to me, and it's the reason why I keep my hair in braids. Like who wants to touch braids? I always get really annoyed when people touch my hair because it takes a lot of time to style. When people touch it, they like to play with it; it gets in knots and twists, which really hurts when I get my hair done. Hopefully, a few people can relate to this and may have a story that's similar.

Hi! My name is **Talia Wilson** and I'm 11 years old. I like to draw, write, read (depends on the book) and watch shows on my iPad. I hope you enjoy one of my many hair stories!

First Fresh Perm

Fatima Ouedraogo Age 17

I was seven years old. I had just gotten my F.F.P (First Fresh Perm). That night before I got my hair permed, I was so happy because I would finally be like the girls in my class who all had a perm. I was going to look cute. I always wanted to be like other people to have friends because I never had friends in first grade. Anyways as time goes by, my hair ends up looking stringy, and I didn't think anything of it because I was young and dumb. I didn't know. Meanwhile, my mom noticed that it was getting harder and harder to do my hair, so then she told me we were going to have to cut my hair. All that was going through my head was (THE BIG CHOP).

I loved the idea, but I was also sad because I thought my hair was never going to grow back. Still, I asked my mom if it would grow back to my long, luscious hair, and she said yes. Then I said yes, let's do it. By the time we talked about it, I was in the 2nd grade. So one day I came back from school, I got ready to cut my hair. My mom and I got all the equipment ready to cut my hair, and we proceeded to do just that. I end up with a short afro.

I kind of liked it, and it did not make me look like a boy. The cut looked cute on me. The next day I went to school. I didn't bring a head wrap, so I went to school bald-headed. I put my hoody on, and the staff at the school were like," take it off,"

so then I explained to them that I cut my hair. They said it was ok to keep it on because I used to get bullied.

Now I am in high school, and my hair looks beautiful.

Thank you for listening.

Good-Bye!!!

My Hair Journey
Kai-De Alexis Age 9

As a little girl, I had very short hair,
which my grandmama knitted with loving care.
She gently held on to every bit
Her fingers like needles
my hair was crocheted.
When she was done, it was a masterpiece on display.
I didn't always like my hair.
It was short and coily
I couldn't put it in a "pony."
But weekly, we would wash and clean it
Slowly, we developed a routine

And my hair grew on me.... literally!
Grandmama is gone now.
Mummy had to learn to cornrow
somedays I rocked a fro or wash and go
And thank God for two strand twists.
It's a staple in our home.
I love my hair.
Grandmama used to say; it's my crown
Even though it is still short
I wear it proud.

My hair doesn't make me pretty
I was pretty all along.

CHAPTER 6
HAIR LOVE

Chapter six is dedicated to the Pongo Teen Writing Program.
The Hair Love writing prompt was created
by Pongo Teen Writing Program
https://www.pongoteenwriting.org/

Hair Love
Alexis Edmondson Age 10

My hair, oh my hair! Sometimes, I want to ask you why you are
so hard to comb.
Other times, I want to tell you to do what I said and
to stop making me mad.
I pamper you by straightening you and washing you at the
salon.
I don't treat you as well as I should
when I forget my hair because I do too many things.
You, oh my hair, are like the rest of me because you are what
helps me feel beautiful.
Yet you are different than other parts of me
because you make me remember
to take care of myself.

Hair Love

London Edmondson Age 7

My hair, oh my hair! Sometimes, I want to ask you why it is so hard to comb.

Other times, I want to tell you to do what I want

I pamper you by washing you.

I don't treat you as well as I should when I comb my hair.

My hair, when I think about you,

I remember the time I tried to comb my hair

And my mom found a chunk of hair, and my hair fell out.

Hair, sometimes, it's like you're telling me to stop combing you.

Hair, oh hair, old friend, towards you, I will always feel you are unique.

Hair Love

Kee'Niyah Williams Age 10

My hair, oh my hair! Sometimes, I want to ask you why you are so hard to untangle.

Other times, I want to tell you are really nappy, and it hurts when I comb my hair.

I pamper you by doing my hair to make it beautiful.

I don't treat you as well as I should when I forget to do my hair.

You, oh my hair, are like the rest of me because you are beautiful.

Yet you're different than other parts of me because you are really nappy.

My hair, when I think about you, I remember the time when I get my hair braided.

Hair, sometimes, it's like you're telling me to pay more attention to you.

Hair, oh hair, old friend, towards you, I will always feel happy and beautiful.

Because I know you are beautiful, and you are a part of me.

My Hair
Amori Singlton Age 13

In the middle of fourth grade,
I decided to cut my hair.
My mom shaved it to half an inch.
I felt like people were going to make fun of me
and dislike me.
I had friends back then, but they weren't as nice
as I thought they were.
I went back to school one day with my hair cut
with my hood on, but my teachers made me take off
my hood because they said it was a sign of disrespect.
And when I did, everybody started laughing in the class.
I felt sad, and the teacher didn't even care how I felt
about my hair and I loved my hair when I was little.
After I got home from school, I ran into my room
and cried my eyes out, and said,
"I WISH I NEVER CUT MY HAIR!"
My mom came in and asked what was wrong.
I said that everybody was making fun of my hair
and didn't like me, and I didn't like my hair.
Because my hair is a part of me,
my mom said that I was beautiful.

I struggled for a couple of years
because people were calling me bald,
and saying I had cancer
and that no one would like me
and my hair wasn't going to grow.
Now my hair has grown
And I can wear braids,
and now I can accept my hair for what it is.
Now I know that my hair
was pretty all along.

Natural Hair

Chance Coleman Age 12

Sometimes, I want to ask
why do I have to have curly hair?
I do not want to have straight but wavy hair.
My curls are really tight, and it gets nappy
and it's hard to brush 'em out
and you have to really treat it—
with Leave-in conditioner
spraying it with water
when it gets nappy
and brushing it out
starting from the bottom
to the top.
But if it was wavy,
I wouldn't have to do all that.
Other times, I want to tell my hair
Wow, you look good today!
Especially on days when I wake up at six on the dot
to make my hair look beautiful.
I pamper my hair by washing it,
letting it be free,
letting it down,

and not tightening it in a rubber band—
When I do that, it's nappy.
The struggle with curly hair!
I neglect it sometimes, like when it's in a messy bun,
so, it doesn't get in my face,
which is useful if I'm doing school,
going over to write,
or I'm playing outside.
My hair is like the rest of me
because it's unique, and it stands out!
Yet my hair is different than other parts of me,
because it's messy
and I'm not a messy person.
When I think about my hair,
I remember the time when I was on a bouncy house
and somebody stepped on my hair
and it got stuck on the slide
and my hair was holding me up
from going down the slide
and someone had to cut it off.
I thought my hair was going to get stuck on it forever
and I started having an anxiety attack.
Yet I can laugh at it now,
though there's still a piece longer than the other
but I'm pretty sure they'll cut that.

It gave me a life lesson
to not let people step on your hair,
but to push them off the bouncy house first!
The day after tomorrow,
I'm getting my haircut really short,
and so, I might not have to deal with all that.
I've dyed my hair a few times,
but I'm tired of it being damaged
with the bleach.

But I want it cut
because it has heat and dye damage
and I want my hair to grow back
how it used to be when I was like 9—
when they were defined curls.
I didn't have to put a lot of products in it
because when I would get out of the shower
it would be moist, and I could just let it dry out.
I will always feel grateful to have curly hair
because I know a lot of girls with straight or wavy hair
want hair like ours
because they want to try something different.
Our hair can do a lot of different things.
Our hair is special and beautiful!

Curls

Ahlaya Kennedy Age 13

My hair is curly.
Kind of a golden-brown color.
I love it.
My hair is bouncy like a basketball.
I love to do my hair in buns, ponytails,
a lot of creative styles and braids.
I take really good care of my hair
and put a good product in it.
One product is aloe and blueberry curl moisturizer.
I wash it once a week
and use my conditioner every day.
It helps it get all untangled.
I love to wear my hair down.
I feel like it really shows me.
I am beautiful no matter what my hair looks like.
I am glad I have a lot of hair.
It goes all the way down to the middle of my back.
My hair is curly.

CHAPTER 7
CROWN AND GLORY

For we are God's masterpiece.
Ephesians 2:10

Hair Memories
Sandra Ali

Ever since I heard of the Unyielding Roots Project, I relived horrible memories of hair washing days. My mother's fingers would become hard steely instruments of unceasing torment as they dug into my scalp, pulling my hair almost I felt out of my scalp.

Then my hair and head would be almost (or so I thought) pulled and PULLED and PULLED

till I finally cried out, which usually got me an:

"Oh, this isn't hurting you, Sandra."

Then she would plat my already throbbing hair with plaits so tight my eyes watered until my hair dried.

Then after a while and my hair had loosened up somewhat and dried, my mama would get out the old

PRESSING COMB!!!!

I would beg and plead (and even though, I promised myself not to CRY!)

My mom would show no emotion at all;

the more I cried and pleaded,

the tighter her lips and eyes became,

but only when my tears became genuine would I see a glimmer of satisfaction in her eyes.

She had WON!!!

AND Then She would proceed to press my hair, which could be REALLY BAD for me depending on IF She had to use a little energy to get me to cooperate.

The pressing comb would be a little hot;
if she got really vexed, it would touch my ear or the back of my neck. She knew just how much torture to use.

Everything became her weapon like the comb, even the parting of my hair was agony.

The smell of burning hair and grease to this day makes me nauseous. And ALL the torture of having straightened hair, the praises of how good your hair looks after a trip to The Beauty Shop somehow ALWAYS fades the next morning when I couldn't get my hair to look like it did before I went to sleep.

I am SO Thankful today for Our natural hair that we women of color wear today that WE OWN, that can't be imitated.

IT'S OUR HERITAGE!!!!!

We NO longer have to use a pressing comb, to hide our natural hair.

But we can FLAUNT The BEAUTY hat TMH (The Most High) God gave to us.

15 But if a woman have long hair, it is a glory to her: for her hair is given her for a covering." 1 Corinthians 11:15

Gift

Anna Lyons

Our Blessed tresses are a token of beauty from the
Most High God.

I acknowledge the wonderful works of My Lord and King.
He has bestowed upon my head a glory for a covering, a
beauty external, but in the chambers of the heart are found
the treasures of that which is unfailing

Godly fear and good deeds.

For this is where true beauty, My glory proceeds;

worship of the Lord of Hosts, The King of all Kings

As he who is most blessed Our creator and Elohim

My hands enlightened me with talents to mold and groom
these strands like a work of art,

A gift he's placed in my heart

Happiness brought to myself and others confidence, a
window to see his glory in another

Bouncy curls, straight, natural, and the latter,

Its unique appearance drawing pleasant attention, creating
opportunities to share his truth,

The word of life thereafter, revelation of a crown unseen

Bejeweled in the radiance of my creator as he shines
through me
My hair, reminiscent to that of a sheep; wool
A sign of everlasting love, from The Master,
A physical reminder that I belong to Jesus, as a sheep of his
pasture,
'The Good Shepard' 'My Jehovah Rohi,' he who leads
me into all things glorious and wonderful,
For wonder is he,
In his unsearchable wisdom, he had made for me
this blanket of beauty,
I bask in all the goodness of the workmanship of his
hands, bowing myself down in honor, veiled as I seek his
face to reveal to me his plans.
I acknowledge the wonderful works of My Lord
and King,
Relishing in gratefulness for such a covering,
A beauty for all to see,
A token of The Most High's gift, a glory.

The Curl of My Hair
De Etta Burrell, October 2019

To curse this hair, I would not dare.
For LORD Father gifted me.
My days abound still full this crown.
My LORD Father gifted me.
Black-brown tinged gray does my hair lay.
Yes, LORD Father gifted me.
Wooley from youth, curled in His truth,
Praise, LORD Father gifted me.
Bushy, nappy, some locks snappy,
For LORD Father gifted me.
Wavy to His touch, yielding to His clutch.
My LORD Father gifted me.
His laws coiled deep from roots they seep.
Yes, LORD Father gifted me.
His works and care comb through my hair.
Praise, LORD Father gifted me.

The Crown of Glory
Mary Aongo

Inspired by these Scriptures.
1 Cor 11:15, Luke 21:18, Matt 10:31

My Creator made sure
He endows me,
with a crown of glory
that brings me joy.
He knows the numbers of my hairs
everyone, He has put upon my head
this is for my glory,
this is for my joy.
You are the covering on my head.
You have kept me warm and well.
You are a unique sign
And every strand is by His own design
I know now, the power
I have to wear you
In style and versatility,
never being ashamed of your ability
Not to be manipulated
With chemicals

That can and do cause cancer

That is a danger to my health and my cover.

You are a part of my temple,

The House of the Spirit of God

And how dare I?

Not care for you the way I

Was made to worship

The Living God

Who gives every good gift

and every perfect gift?

That is from above!

I am endowed with a heavenly gift.

You are my crown of glory,

For my very own joy

The very hairs on my head

Are numbered

And my Maker knows it

Though I cannot count it.

And He assures me,

None can fall without His permission.

None can be plucked,

For He has put each one on my head.

This is for my glory!

This is for my joy!

So, today I wear my crown with pride,

I love my crown, and it's mine.
It is for my glory,
And this is my joy.

Mary Aongo is the author of Healing Songs, available on Amazon. www.joycollections.net

Who Taught You to Hate Your Glory?
Rhoda Love Hill

If God said, we were made in His image and likeness.

That we are fearfully and wonderfully made marvelous are thy works!

That our hair is our Glory!

Who taught us to hate our glory??

Is it family, friends, the world, self, and the trick of the enemy!

Changing the original form in which we were created!

I was created with beautiful, thick, strong hair. But I wanted anything but that because I was trained unknowingly to hate my Glory very young.

I was called a nappy-headed little girl.

I was permed at four years old, not a choice of my own.

It was not considered beautiful.

Only when I changed it I was noticed for my beauty!

"Wow, you look beautiful now."

I was not told this at four,

so I questioned was not I before?

After going from kinky to straight,

I was blown away. I can run my fingers through my hair; it moves in the wind, and people like my hair now.

141

This is what makes people slaves to wigs, extensions, perms, and hair dyes when you cannot live without these things! They become an idol in your life. But you do not realize this until you are free no longer a slave to that thing.

My Glory was never seen; it was always covered.

When I decided to go natural, I was ashamed for some time.

It took God to help me with this. That I was beautiful just as He made me and that I did not have to add to the beauty that he has already blessed me with.

That it is not Him who it pleases but man.

That if he wanted me with this or that, it would have been so.

I began to love my hair and appreciate it in ways

I never did. We can always think of things or ways to change something. But to embrace it is the biggest gift. Be thankful for your thick or thin, long or short, straight, wavy, kinky, and coily. Light or dark change, not your Glory! If God wanted us to have this or that, it would be so! He created it all and said it was good! We are perfectly made. I choose to keep my Glory and changeth not! Glory to His name!

The Main Event
Dana F. Brewer

I am my hair.

My hair is me.

Long, nappy, fierce

God-given and regal.

It is mine.

Don't you dare speak on it.

Speak on this mane that fiercely guards the secrets of my people,

My hair pays homage to warriors and queens.

It will not be tamed.

It will not succumb to the heat of society.

It will not conform.

My hair has traveled the world with me

and stood up to scrutiny.

"Is that really your hair?"

"I thought black people could not grow hair.

Can I touch..."

Really?

My hair has fought to survive these twenty years.

Strand wrapping around strand,

each one reaching one.

Making it stronger than the sum of its parts.

My hair is a crown that sits atop a head that God made.

A beautifully adorned head that thinks, feels, sways,

and moves.

They tell me it isn't cute.

It makes some feel ashamed.

It puts me with the wrong crowd.

Well, it makes me proud.

I am my hair.

My hair is me.

It is mine.

Dana Brewer is President & CEO of Computer Information Station, Inc., a Managed Services Provider and IT consulting firm located in the San Francisco Bay Area. Website: http://cisnetworks.net.

God Gave Us Go(o)d Hair
Amani Sawari

Maintaining my hair

My crown,

My essence

The fruit of my spirit

In it, I develop

God's fruits of the spirit

While detangling

Separating and removing buildup from the roots

Every single one of you

With your own mind, shape, and mood

Moving in your own direction

Individual and crossing hairs at each intersection

You require management, patience, and care

Threatening to tangle

When I am lazy or unaware

You'll always be there

Standing and spreading

Bouncing and shedding

Waiting to be transformed

Braided, twisted, or bantued, Never the norm

Your styles hit the West like a storm

On my head, you strike and adorn
Revealing those who are ignorant
And educating the uninformed
What are you if not a gift?
A blessing
A learning lesson
Her Hair is her glory
Go(o)d hair is my story

Amani Sawari is a writer, activist, and founder of SawariMedia, a communications and civic engagement organization serving those inside prisons throughout Michigan and across the country. She has created multiple visionary publications, including the Right2Vote Report, which aid in distributing messages and building community among participants in the prison resistance movement on both sides of the wall in over 30 states. Sawari, a 2019 Civil Rights Fellow with the Roddenberry Foundation, is a known speaker at conferences and universities on issues related to voting rights and prison abolition. She graduated from the University of Washington with her Bachelor's degree in both Media Communication Studies and Law, Economics & Public Policy in 2016 and currently lives south of Detroit in Michigan.

Unyielding Roots: What is Your Hair Story?

For we are God's masterpiece. Ephesians. 2:10

Hair Wars
Kiana Davis

I grew up
under the indictment
of tangled roots
beautiful only after enduring fire
I learned that my hair
could not be trusted
it was complicit
in its refusal to
alter its coarse texture
so that my hair could be
everything it was not created to
be.
for years I subdued
my tightly coiled strands
unconsciously rejecting
the fearfuly and wonderfully
made hair God had given me.

CHAPTER 8

STYLING AND LOVING MY CROWN

Wrapression
Amani Sawari

Right arm comb in hand
8:00 p.m.
Intention
Mirror reflection
Playful living distracted.

10:00 p.m.
Conviction
Smaller mirror reflection
Coercing unforgiving words
Fold, Tuck and Tie

12:00 a.m.
Repetition
Blind eyes open
Prolonged wishful thinking

2:00 a.m.
Neck knots
Headaches
Forehead lines

3:13 a.m.
Questioning
Why do I willingly endure?
Sleep-deprived nights

6:30 a.m.
Reflecting
Tucking back microaggressions
Convincing crowns to lie silently down
Suddenly saved by slices of eager sunlight
Left-arm comb in hand

8:00 a.m.
Untie, unpin, unwrap
Strands sweep from right to left Finally
freed from nightfall repression.

Twisted Locced King
Amani Sawari

Tightly Wound
Curly Committed
Long-suffering
Ever possessive
Chocolate
Solid & Sound
Fiercely spirited
Enlightening
Newly progressive
Deeply thinking
Braided & Bound
Pangs in Pained
Neatly Covered
Styled Impressive
Always present
Born Crowd
Perfecting patience
Naturally Enthroned
Uncut
Forever intertwined
Inspired by my locced love

My Hair
Anonymous

It is my hair!

Why do you feel like I need to share?

Do you want to touch it?

Really?

Yes, I do care!

Do you realize the risk that I bare

for wearing my twists?

For not succumbing to the 'norm' and looking like this.

Now my professionalism you are questioning,

For being authentic and not acquiescing.

Who said you get to determine what is acceptable?

My natural hair *is* beautiful and more than just palatable!

It doesn't matter about your look of disdain and scorn,

Cuz, **I** get to define the definition of hair norm!

From Here to Thair
V. Tina Christian

Hair, what hair?! I was born bald as a baby's behind! My head matched the rest of my body with no contrast homogenous. No "fright" of black hair for me, like with my 2 brothers to distinguish their soft, beautiful, baby bodies from their hair. In fact, back then in the hospital nursery, I was so homogenous, looking like the other white babies, that when it came time for feeding, they brought my mother, not me, but a WHITE baby! Mom corrected that situation real fast!

When I was three, Mom sat me outside on the grass. She faced me in front of the kitchen window so she could watch me. Suddenly, the teenage neighbor boy shouted out his window, "Hey boy!" I still barely had hair on my head at the age of three! Again, he called out, "Hey boy!" I whipped my bald head around and screamed, "I'M NOT A BOY!" Mom said, she thought to herself, "I guess I won't have to worry about that girl."

By four, my hair grew. Mom was Japanese, and Daddy was Black, so that made for a nice blending. When I was six and Daddy was overseas, I begged my mother to cut my hair. Mom said Daddy wouldn't like it. Men just love long hair, and Daddy was no different. She compromised and only trimmed my hair and gave me bangs. When Mom sent our family Christmas pictures to Daddy, he was surprised by my bangs. Needless to say, I got over that phase, but that itch would get to scratchin'

every now and then, and when Daddy was asleep or at work, Mom would give me bangs.

In the '60s and '70s, my hair was down my back. Hair was important and a strong part of our identity. I am Japanese and Black and present as Black. I had naturally straight hair when afros were everywhere. Even though I would be complimented for my BEAUTIFUL hair, I still couldn't wear an afro. I struggled to fit in, although I never let it show. That was just how it was for bi-racial kids of that time. Instead, I began to embrace my long, beautiful hair, and my favorite Broadway play at the time was *Hair*.

Even though I hadn't been bald for a long time, my brothers still teased me. They had this song that would bring tears every time. "Hot dog, chicken, and gravy, here come Tina wit tha bald head baby!" And they would be cracking up exaggeratedly. I just couldn't escape those bald days.

During that time, there was so much change happening. We had the civil rights and women's movements, Watergate, and the Vietnam war. Times were changing, and so was I. It was time to cut my hair. Everyone was in agreement except Daddy, but by now, I was 15. There would be a back-and-forth debate and tears, but that Saturday, Mom and I went to the mall, and I got my hair cut.

I've been bald, have had long hair and short hair, curly and straight. I've lost half the hair on my head, had alopecia areota, and now my hair is gray. (I color it.) I've went gone from *Here to Thair* with my hair. I heard Oprah once say,"her hair is her crowning glory". I say the same thing.

Hair Hazards
Georgia S. McDade
5/11/11

Generations of women endured and endured

Hot combs

Strong chemicals

Burned scalps

Scarred necks

And other unknown, unspeakable, possibly worse injuries

All for the sake of beauty

All in the name of beauty.

As we contributed and contributed to the coffers

of billionaires

who routinely failed/fail to see the beauty

we ourselves often do not routinely see.

Georgia S. McDade, Ph. D., is an author, educator, and beloved community member. Along with Jim Cantú, she co-hosts KVRU's (105.7) "Hearts and Soul website: https://www.georgiasmcdade.org/. I

Pride, Crown, and Soul: The Power of Black Hair
Sarah Morgan

Black hair is unique, special, and something to be proud of. Because the texture of our hair is different, historically, we have struggled with our identity and the things that set us apart. We've been made to feel ashamed of our hair and our bodies in their natural states. Systemic oppression has deemed our hair as improper, unhygienic and restricted our choices in how we express ourselves in any professional environment. Now, Black women are accepting our natural hair and its beauty as a vital part of our identity.

Black hair is so versatile, and there are so many different hair types, ranging from loose to very tight curls. People should appreciate all of these variants rather than succumb to the tendency of glorifying whatever style is closest to straight hair.

Avery Wright, a sophomore, said she prefers a puff bun for hair. 'I like having my edges done. I like how the curls are defined. It's my go-to. I take care of it; I make sure my curls are always popping because it takes time and effort, and I make sure I do it the way I want." Ayomi Wolff, a junior, prefers her afro. 'I think [my hair is] very important to me, a big part of my identity that developed as I have developed, a part of me that I've struggled with, as well as tamed and let loose... I used to be so bad with my hair because I didn't know how to deal with it. I used to cry because I didn't look like the princesses in my books." Sophomore Angeline Daniels shared a similar

experience with hair, saying that it got damaged in elementary school because 'People would throw pencils inside my hair, and I started straightening it... Now my curls are coming back, and slowly we're on a journey to natural."

My hair is my pride.; My hair took a long time to get used to, and my hair makes me who I am. I used to wish that my hair was straight and blonde. I'd love to explain to a seven-year-old me that while white beauty standards temporarily ruined my self-concept, I would later pick up my own pieces and become strong, skilled, and satisfied with myself.

Black people have created so many hairstyles: cornrows, afros, braids, box braids, slick backs, afro puffs, twist-outs, you name it. I'm so proud to have a heritage where the people have created. We have so many styles to work with to flaunt our differences instead of hiding them.

I am happy with my hair. Even though it takes more work, it gets tangled, and people touch it when I've asked them a thousand times not to. I love my hair, which sits in the middle of a loose and tight curl. Regardless, I appreciate every curl type. I love Black women, and I love that we can do anything we want with our hair because of its texture and versatility. I'm hoping those with Black hair can come together and see that we've all shared experiences and can appreciate each other for who we are.

Untitled
Rayna Stewart

Broken combs, snapped elastic, bent bobby pins
Lost bonnets from wild sleeping nights
The style that the beautician just finished. Ruined.
I am not kind to my hair.

The laughter rings as loud as a church bell
Why is there discussion about it?
My untamed edges, my un-styled hair, my unruly hair
I loathe my hair.

Products consume my bathroom sink
Hours spent not to get the results
Tangles, Frizz, Poofs.
Please cooperate with me, hair!

New curls emerge from my roots
Strong. Nourished. Plentiful.
Standing tall, flowing as I move
My hair shall be nothing but free.

CHAPTER 9
CHILDHOOD SCARS

Wearing It Bolder
Valarie Howard

As my mother would wash my hair
and give it care,
it hurt.
To where I would dig my chin under my shirt
I wondered, "Is there anything that would work,
Because this hurt."
My kinks and coils were like most
but to me, my hair was a joke.
Not because it had coils and kink.
But it was nappy with no slink.
At least that's what others had me to think
It didn't lay on my shoulders.
Not wearing bolder until I got older
No more digging my chin in my shirt
But still, it hurt and I'm older
Due to the World being colder
But I will still wear it BOLDER.

My hair is my Karma. What have I done?
How can I redeem myself?
Raquel Poteet

My hair is an entity.
I've been hauling my whole life.
It took me deep consideration when I was asked
if I wanted to submit my hair story. I'm not so sure my hair
deserves a story considering all I've been through.

My hair has always been a problem for me since my birth.
I was considered the unlucky one in the family, and
those were some of the statements I heard growing up:

"You have the worst kind of hair in the family."
*"Your hair is like your grandma's. Lucky you, it is not red
like hers."*

My classmates used to say:
*"You look like a Mickey when your mom does your hair that
way."*

My middle sister was the lucky one as she inherited the
Indian side of the family. My mom loved to braid her hair,
and she had long braids with colorful bids.

My hair was also done neatly but as a child

I did not understand I could never, ever have long braids like my sisters. So, I cried!

In teenage and early adulthood, life is crueler to people like us. I could not understand the reason behind having my kind of hair. My mom was right - my hair was the worst in the family.

In high school, my dream was to go to a popular hairdresser that all the girls would go to in my town. When I was finally able to afford it, I made an appointment right before my prom. I got there at 2 pm and left at 8 pm. He tried to give me a blowout and style my hair for hours. In the end, he was all sweaty, and I looked like a lion. It was so embarrassing for both of us, and I felt so guilty!

I've grown up with hair insecurities based on my aunts' stories. Whenever they would visit us, something bad had happened to their hair, such as burns, fall out, wigs, baldness, you name it. At the end of their lives, they had all succumbed and adopted handkerchiefs, pretty shortcuts, or totally shaved styles.

Now, in my late forties, I do not really care anymore. I have tried clips, extensions, braids, wigs. I have been through countless types of relaxers, been burnt, I have lost patches of hair, and the list goes on and on.

I am realizing I'm turning into my aunts. Now I understand why they succumbed and accepted the reality. Simply because it is what it is!

My mom was right - my hair is definitely the worst in the family, and it probably deserves a story.
That is how I will redeem myself.

Raquel Poteet is Brazilian and has been in the US for 12 years. With BAs in Education, Translation, Interpreting, and a MASTESOL, she has been teaching English as a Second Language and Spanish for over 20 years. She loves the opportunity to build community in class, learning from her students, and exploring their amazing cultures. www.raquelpoteet.com

I Just Wanted to be me
Collinda Pennyman

Growing up as a kid, I never really placed too much emphasis on hair. My mom always made sure that my hair was neat and clean.

I just wanted to be me.

I never really noticed that my hair was different from other girls. We all had our hair in the same way.

I just want to be me.

As I got older, I learned that people sometimes judge you based on how you wear your hair.

I just want to be me.

Society considers you pretty if you have long hair

and my hair was never long.

I just wanted to be me.

I think that you should wear your hair based on what makes you feel good. I personally remember having my hair fixed like Pippi Long stocking as a kid. I never focused on her race. She was just Pippi to me.

Happiness comes from within and being beautiful no matter your race or how you wear your hair should be a matter of preference and taste. We should not be defined or classified based on what society thinks we should be.

I just want the freedom to wear my hair and just be me.

'Shave it, Slay it, Display it"
by Rachel Zhang

I decided I wanted to start from scratch.

Shave it all off and grow a new batch.

What I didn't know then was that I was attached.

Not to the hair, but the girl I "thought" matched.

She always had "good" hair,

Ever since she was a kid.

Her mom set out to grow it long,

And that's just what she did.

Hair appointments every week.

If she missed one, God forbid!

She told me, "Brown girls

with nappy curls are never accepted."

So, she carried mother's words with her

Everywhere she went. If it had anything to do with hair,

All her money would be spent.

"OMG! your hair's so long.

You should totally be content.

You look just like black barbie!"

I still don't know what that meant.

Now 16, she's does her own hair,

Though, never shown how-to properly.

She didn't have the time to primp or prime,
So, in the bun, it went, sloppily.

When she got off the bus and was met with fuss, gasps, and mockery, she didn't understand how the kinks in her stands could attract so much snobbery.

Her hair was unkempt

Due to certain factors.

Damaged and fried

by dye and relaxers.

But she didn't care,

Length was what she was after.

The health of her hair

Really didn't matter.

Now she's 32 and has had time to reflect on chemical burns,

Over-manipulation, porosity and neglect.

Never once in her life did she show her hair respect.

Putting your worth in what's on your head will never be correct.

We have to love our tendrils no matter what the texture.

Who cares what society may think, say, or gesture

Pick your fro or wash N go whatever is your pleasure. Or you can shave it, slay it and display it....

All with ZERO pressure.

Learning To Love a Country That Caught on Fire
Leija Farr

The bleach shrivels into my scalp.

Loosening everything I've known.

Burns a country into my skin I hurry to forget.

Takes with it what I believed to be beauty.

Strand by strand.

I eulogized each dark brown coil.

I cry and pray for an overnight miracle.

It never happens.

This new head of hair

I have been given is abrasive and cleaved.

Mispronounced and never settled.

I hurry to hide this unorthodox and unruly.

Shape my hair under hoodies and hats.

It lives there for some time, touched by an occasional oil.

With time, I embrace my hair again.

I name each strand that has blossomed and become
an expert in braid-outs.

I take each tear I cried to water the strands

I misplaced.

Finally, give my curls a home they can find easily.

I receive a country that does not burn or take
anything with it.
Instead, I watch as it grows.
I watch as the sun lights every
curve and crevice
and makes my hair iridescent.
And I fall in love again.

Leija Farr is a literary artist from South Seattle. In 2015, she served as the first Seattle Youth Poet Laureate and since then has shown her outstanding abilities within the arts scene with her passion for social justice. Since she was always interested in writing, it came as no surprise that she would curate poetry workshops and become a published author of the manuscript 'Outweigh the Gravity.' She has been featured as a person to look out for in Essence Magazine and has opened shows for revolutionaries such as Angela Davis and Saul Williams. Leija is currently working on her next book entitled, 'A Home for The Fruits to Bruise

Dear Hair

Euneka Parr

Dear Hair,

It has been a journey, but we've finally come to an understanding. Since being a little girl, and now being a young adult, my growth has helped me learn a lot. From breaking all types of combs, to not breaking any; with the exception of a few with the blow dryer comb piece.

As a little girl, I used to hate getting my hair combed because my scalp was sensitive; people to refer that as being tendered-headed. I had to settle with easy hairstyles when I was a little girl. For example, some of the hairstyles I use to rock were ponytails with twisties ended with bobbles or barrettes, braids ended with beads, and two puffs or one big puffy ponytail.

In my pre-teen years, I began going to the hair salon and along came a new journey into different hairstyles. My first experience was great. I started off with a shampoo and conditioner then, sitting underneath a blow dryer having my hair combed out. The woman doing my hair noticed I needed my ends trimmed, so she started by pressing my hair with a hot comb. That hairstyle lasted for at least two weeks. I wrapped my hair up every night and combed it out in the morning. I realized my hair was no longer virgin because of having it straightened, so I knew I was getting older and more responsible. I decided to keep getting braids and stay away from putting heat in my hair on my own. I didn't want to damage

my hair from using a lot of heat; unless I was going back to the hair salon to get it pressed and trimmed.

The routine I do now to maintain my hair is: deep conditioner, hair masks, shampoo, conditioner, detangle moisturizer, combing, parting into four sections to blow dry it out, and lastly, I oil my scalp. When I want to rock my natural curls, I switch up the routine a little. After I detangled and comb my hair, I apply curl moisturizer and then, I twist and style my whole head. After I finish, I put a bonnet on. As I got older, I realized my hair had gotten thicker, and now I have more control, so it's easier. I do deal with bad hair days or some days my hair doesn't want to act right; It's a part of having beautiful coarse hair. I love embracing my curls, natural puff ponytails, and any other hairstyles I wear. Thanks for the memories I have, and I look forward to what's more to come.

Naturally Straight Hair
Phe-Shay Locke

I love the coils. The way the shapes resembled my ancestors' smiles. I love the kinks that many struggles to train in society's eyes. I love this hair. I do, but for a while, I believed it was naturally straight. It was naturally Anglo. I believed the way my hair would fit neatly groomed into a ponytail was because I was rare.

From the ages of 2-6, my kinks and coils were welcomed by intruders. As I yelled and screamed from scratching my scalp to red, the blood-filled my fingertips and my mother's sorrows with confusion. We later found out that I suffered from a disease, Psoriasis. I was prescribed a medication, a special shampoo that smelt like a rotten egg. I can remember being in the kitchen, and as she massaged my scalp, lathering in the medicine under the warm rushing water, I cried. Something about getting your hair washed as a kid was so dramatic. The medicine didn't work. I still found myself waking up with scabs all over my scalp and blood under my fingernails. I'd wake up crying or unable to sleep because of the pain. Soon my mother steered away from the doctor's advice and went with her own research. She took a chance and decided to try, "Just For Me" relaxer for kids.

Kinks are the wounds of my ancestors

That my mama couldn't handle

That no black mother could handle

But they snatched

and smoothed out

To perfection.

I didn't know what a relaxer was. I just knew the pain went away, and the scabs were completely gone. From that moment on, I had straight hair. I loved my straight hair. They loved my straight hair. Now my mom could manage it. Now my cries could be silenced. I could be easily malleable. Black in skin tone, but my hair was questionable. I can recall the nostalgia on the playground as the kids would ask, "what are you mixed with?" "I'd say nothing; I'm black." "But your hair?" "

I'd say it's naturally straight."

I didn't know better.

We move in a time where no one appreciates our value.

Slowly trained to be finely groomed.

To know finely groomed

We think and become finely groomed.

The moment I cut my relaxer out. I felt I looked like a boy, and there is nothing wrong with that. But it took a while to grow on me. Almost crying from my newfound curls. I learned as time went on and my ancestors smiles began layering on one another. My kinks and coils were magic.

Cutting each strand and living with a plantation on your head

Is free

How ironic

But it brings us back to our history.

Our truth.

Our beauty.

Phe Shay Locke is a Washington State/University of Washington graduate who has a passion for words and educating. She frequently performs at open mics sharing poetry about African American injustices and self-love. She's a believer in positive language and plans to inflict her theory of positivity into the youth. With her gifts, she trusts one day, she will move toward the erasure of racism.

Until then, she will continue to learn her roots and share her knowledge. She owns her own publication business named Paige Publications and has two published books, Fresh Strawberries and Okra - Lady Fingers. You can support Phe Shay Locke by purchasing her book on or subscribing to her website paigepublication.com.

Three Natural Daughters
Leilani Farr

They are my three natural daughters.
Each with their own coily, kinks, spiral, wavery,
and locs
Their textures only slightly describe them
and their hair.
For there is more to them than meets the eye.
Baby girl: scolding water
Hurting and healing locs.
Embarking upon finding herself in the preteen times:
straightened, trying to fit in, and an accidental afro.
questioning beauty
eventually loving self and in turn, loving hair.

Spanning the ages young not knowing
what to use and doing the best we could
Sometimes it would be in the matted middle,
edges before they were in style,
hair cut into a bob,
evolved into the family's hair whisper.

Dear Hair

Lynne Hurdle Price

Dear hair,
I have tried
on several occasions
to write my hair story,
but it is still so painful
that I continue to stop myself.

Lynne Hurdle Price is a conflict resolution strategist, facilitator, speaker, and coach. In addition, I am the author of the best seller, *Closing Conflict for Leaders: How to Be a Bold Leader and Develop a Kick-Ass, High-Functioning, Happy AF Team.* www. Lynnemaureenhurdle.com

CHAPTER 10
MY HAIR-OLOGY, MY STORY!

Don't Touch My Hair!
K. MHina Entrantt

Don't Touch My Hair with your judgment and stares.

Or look at me with concluding eyes of "why."

As though My Natural Hair is Unaware of your standard of Only-you-beauty.

That has Never recognized, included, or celebrated me and mine—

As Beautiful or Divine.

It is quite interesting that I see you so well,

but you lack the vision to see Me & my Hair,

for the richness that it is—and that it is All—Mine!

Don't Touch My Hair with your "If only's" ...and "why don't you" ...Do something 'nice' with all of that!

As though my hair follicles are less than the growth of the Utmost.

My Hair Tentacles touch the unseen, get messages of Creation Themes.

My Hair stands to attention at the least mention of Ancestral Visions & Dreams.

My Hair is a Testimony of continuous Reigning Drops!

Of Kings & Queens, Mathematicians, Astronomers, & Physicians.

So, let me Be clear, in this atmosphere of Hair Beauty & Hair rejection,

It is not by Chance, happenstance, or lack of care that I wear my Natural Hair—

It is a Choice! It is My Beauty Voice!

It is a Salute to My Tribe.

It is My Statement of Being Alive!

Dr. K. Mhina Entrantt is a Radio Host-1150KKNW.com (Mondays 5 pm, PST, 8 pm, EST) Conversational Spanish Instructor, Motivational Speaker, Workshop Facilitator, Author, and award-winning Poet. As a Mental Health Administrator for over 30 years. Dr. K pioneered culturally inclusive mental health services for people of color, migrant workers, and language barrier interventions for Spanish-speaking clients.

Contact: drkworkshops@gmail.com, FB, Dr. K's Abundance

What you Doin' With Those Twiggs in Your Hair?!
K. MHina Entrantt

"What you Doin' With Those Twiggs in Your Hair?"
Is what my friend said as he looked at my starter locs,
With a frowned face and furrow on his brow.
Are you going to keep it like That?!
He said as he shook his head in unbelief!
I met all of his frowns,
with a Smile that came
From deep within
When you've learned how not to depend on
Acceptance or Compliments from other folks.
The Freedom in my hair boldly met his disbelief stare.
For in his mind, the only beautiful kind
was the pressed hair with No Kinks In the air!
Well, if that's what you wanna to do...I guess??!!
Me &MY HAIR was so Free that his opinionated stare,
Was blocked by my Not-your- Business-Dare!
He walked off, shaking his head in disbelief,
I turned around in a circle and did a Relief
Dance or two, Celebrating My Truth!

Family Locs
Ja'Net R. McDonald

It seems eons ago now, but looking back to the fall of 1994 and my freshman year at Howard University stirs up a plethora of emotions. Unbeknownst to me at the time, I would only complete one semester at "The Mecca," but that illustrious HBCU left numerous indelible impressions on that then 18-year-old, wide-eyed babe. It was then, specifically in December of that year, that I decided I would no longer torture myself with caustic chemicals that every month left scars on my scalp as well as my psyche.

My brief stint within Howard's hallowed halls, especially my dorm, seemed to me a trek into alien territory. Not only did I witness beautiful men and women in every hue of brown, from the creamiest ivory to the smoothest vanta black, but for the first time in my life, I beheld the widest array of natural hairstyles. Here, one sister sported locs like fuzzy antenna sprouting in every direction, and there a militant buzz cut with stylish designs waving at me as its owner strode past. So much variety stirred up questions within me, the foremost of which became, 'why do I perm my hair?" Quickly and without warning, my subconscious replied, 'to be presentable." I was shocked and disgusted by the revelation. I was also empowered.

As that last shred of permed hair broke and came off, I felt freer than I ever had! And I've never looked back.

Almost 20 years later, I still sport locs and my whole family. People ask, "What prompted your decision to loc your children's hair?"

I answer my eldest son asked for locs when he was around 3 years old because his father and I both had locs then. (I have since both cut and restarted my locs). When I decided to begin a new set of locs my daughters requested them also. Their hair was thick and hard to comb, so there was lots of crying, pleading, bargaining, and flared frustrations whenever it was "hair night."

So locs seemed an attractive solution. No more combs, no pulling on the hair, a win-win for us all! When I started my sons' locs, they were 3 and 4 years old. My daughters were 4 and 6 years old, respectively. I have asked numerous natural hair loctician, and they do not recommend locs for children under the age of 3 years old. A child's hair goes through many stages before it settles into the permanent texture that the child will have during its life. Immature hair, which usually sheds easily, can break off from the weight of the locs.

My immediate family's responses, save for my very traditional mother-in-law, were positive and heartening. My younger nieces love styling my daughters' hair while my siblings shower both of my daughters with encouraging affirmations.

I know in mainstream vernacular; my chosen mode of follicular expression is referred to as "dreadlocks." I find that term to be a regrettable misnomer because firstly, there is nothing dreadful about my magical tresses. Secondly, ironically my locs actually have been the source of my freedom.

Freedom to be me as God made.

Freedom to acknowledge and own my culture. The freedom to embrace my kinks and view what I had mistakenly believed to be a flaw into a most glorious asset.

My locs have set me free!

Ode to My Locs
Ja'Net R. McDonald

Locs
Licorice hued
Keratin ropes
At first, new growths yawn and stretch
Crest of my hopes
Tickling the basement floor of the sky
Follicular record of blessings
Trials
Repository of elixir of me
Kinky, twisty vials
Skimming my ears
Brimming mine eyes
Time moves as the crow flies
Now my wondrous locs
Play about my shoulders
Wet after washing
They make the cold colder
I call them mine
But they're more like
A conjoined twin
Somewhere where I stop

They seem to begin
What was I doing
When this crook formed?
Was it after I had delightfully laughed
Or sorrowfully mourned?
Holding my baby girl's hand, mayhap
Or aligned my breaths with hers
As she napped on my lap

Locks
I don't dread you
I never will
A mystery funneling from my scalp
Visible DNA spill
Eager fingers search through
Stray tendrils catch on nails
So patiently, I must go
Strands caress palms
As we explore one another
In time, in time we both grow
My locs are open links
In a closed chain
Binding me to ancestors unnamed
They are reins that bid me to move
Or spiky crown, which daily festoons

So far, I've birthed two sets
Now gestating my third
Who would've thought
Wound, bound hair
Could make one feel
Free as a bird?
Indeed, my many locs
Are my defiant manifesto
Proclaiming, no
Declaring
 "THIS! IS WHO I AM!
I WILL BE AS GOD MADE ME!
NOT DEFINED BY ANY MAN!"

On a day, years ago
I parted my locs
Dangling as willow branches
Obstructing my view to see
 Surprised beyond tallying
There in the mirror, a glimpse
Of she that is truly me?

Our Crown
Janice Fields AKA Mz. Gifted

It is our crown,
Our hair does not define us
but we wear it as an expression of who we are.
And it is beautiful
From tight curls
To lose rings,
Crochet, French, box, knotless, or cornrows.
We weave simple and complex patterns of exotic
Loveliness that only those descendants of the motherland
can design.
Senegalese, tribal, goddess, lemonade or locs
Wearing it short and cropped
Sassy and sweet
Straight or natural or
long and flowing down the small of our backs
old school big Afros with a pick or rocking it with our Afro
puffs.
Just grooving with what was given by the creator.
It is still our beautiful
Our crown
Which fits oh so perfectly with our flawless melanated skin

Trust the Process
Yogii (Yolanda Barnes)

Trust the process
Lay your head on the inside of her thigh
Allow the hands, with fingers placed in the valley of parts
to
Access the new growth
Allow the teeth of the comb to break open braid
Allow the unraveling of your presentable to
Be free
To be bold
To be.... dirty...
gritty "Girl what you been into"
but be ready to receive
The water...trust the process
The bubble of shampoo and
smell of fruits you've never eaten
endure the hurt of neck on wet rolled up towel...
We will come out clean in the wash,
Co-wash,
And we will sit in the condition
As the coldest of water shocks, you into the submission...
learn the difference between dry and towel dry

Allow heat to penetrate the fresh, clean

To coax out the curl, we will soon suppress it into

Protective style...

Trust

The

Process

The mission is prim and proper, blow-dry and hot comb ya'll

ever smelt burnt hair...

we are almost there...

But not before the grease,

some cross between anointing and cooking oil

We are blessed if we come out without burnt ears

or even

Feeling the heat...

This is how we learn to trust,

Follow head directions, marionette style

And not so squirm, shimmy or shake...but sit still and

Trust the process...

Because if you don't, you will be processed...

and stressed about losing your edges

The break-off for the trade-off. . . the convenience traded for the comfort in learning the process

And how to trust it...

How to be audible about your level of pain

How to work together like a braid

How to cover like grease

How the part still makes a whole

How the heat presses the curl straight til it rains...

learn to live fro free

because it's a process,

just

Trust it.

CHAPTER 11

THE SOUL OF THE MATTER

"3C"

Caitin Lainer

The complexity of hair in African American culture is something that I—as a white person with straight blond hair—was not inherently familiar with for most of my life. When I began working at a group home for young children, I began to notice how the black children's hair was not taken care of—and they noticed. I had a 7-year-old apologize over and over about how long it was taking for me to comb her hair because no one had touched it in weeks. I watched the black kids get denied haircuts every month because the volunteers did not know how to cut their hair.

I saw staff members brush off a request to help comb or wash a 6, 7, or 8-year-old's hair with a simple yet detrimental, "I don't know how to do your hair." These observations opened my eyes to hair discrimination, and with some more research, I discovered that this complicated hair relationship has been forced upon African American people for much too long and in many different ways.

I decided that I wanted to explore this even further for my class project, but I was not sure exactly how to do it. Since photography and stories are two art forms that I'm passionate about, I decided to photograph some pictures to go alongside quotes from stories I have found. My best friend has done some African American hair care trainings for group homes and

foster parents, and I was so thankful for her willingness to help me with this project. Her hair type is 3C.

Photo by Eye for Ebony on Unsplash.com

Resistance

Kiana Davis, *Digging for Roots*

"I am angry.
because black little girls
are forced between knees
and straightened into
commercialized beauty
learning that naturalness
is a radical step toward severed African roots."

Parrott Family
Wade and Ayana Parrot

We, the Parrott family, take our health very seriously! What goes on in our body is just as important as what goes into our body. We find that health and beauty are seated at the table of simple, whole ingredients from the natural world. This is why, after our daughter struggled with food allergies and eczema, we took our already healthy lifestyle to the extreme!

We have many distinct hair textures in our family. I always tell my daughter that every being on this planet is beautiful, special, and unique in its own way. The diversity and beauty of our family's hair textures are a welcomed concrete testament to this idea for her.

To keep our hair beautiful and natural, we had one choice--do it ourselves! Many products are riddled with pesticides, harmful preservatives, and other synthetic ingredients we find unnecessary. So, we took matters into our own hands and started making a simple, natural hair product by combining Coconut Oil with Shea butter and Vitamin B serum! Our whole family uses it now, and our hair has never been more healthy. It is true what they say beauty starts from the inside. I remember this every time we get compliments on our natural hair, and I recall the journey it took to get here!

Dope Black Dad
Jamal Farr

I love my daughters hair.
I love my wife's hair.
I love my mama's hair.
I want my daughters to know
that they get their roots from Royalty.
There is not much I said to affirm them
but more of the Action
They are going to hear they are Beautiful
Strong, a Blessing, and a Gift every chance I get.
I want their teachers, their employers, and
the community to know:
That is how a black woman wears her Crown
is how she gets Down!

Learning my Daughters Hair
Wendell Donaldson

My learning about doing and working with women's hair began only once I had a daughter.

I knew nothing about texture, washing, drying, or anything! It was not difficult in the beginning because their mother took care of most of it, and I just watched and helped when I could. But once my girls were ages four and two, their mother was deployed, and I had to take care of it on my own.

That was very hard because I was terrible at taking down braids and washing. My first time taking out braids, it took me two hours! I was determined to get that time down because my daughter could not take that long sitting waiting for me. So eventually, through extensive YouTubing, I got better. I was also able to get them kids sizes bonnets and hair accessories to make sure the hairstyles stayed kept up as long as possible.

I want them to be confident and know that their hair is unique to them. I want them to never try to be like how every else's hair looks. I want them to be proud just that they should be proud of every link and curl because it makes them special.

I also want their teachers to never scold them for how their hair is different from them- if they happen to be teachers who do not have hair like them.

My Hair
Alistair Pierre

Thick and lustrous, nicely textured, uniformly brilliant, damply tangled, artfully messy, magnificently thick, soft, and wavy.

From generations handed down and from culture was it sustained, from the roots to the fizzled ends, my hair symbolizes my history and where I'm destined to be. Well, that's what society says.

To me, my hair symbolizes nothing more than the essence of my fathers,

And I was taught by them that the wired thick texture of my hair doesn't matter.

The real value of what we carry is inside us.

It doesn't matter what we are, where we are, or who we are. It doesn't matter where we're from, whom we came from or what we might see.

Our (My) real value and symbol is the deep character that's embedded and manifested from the inner me.

My hair symbolizes nothing if it doesn't represent the leader that's hidden inside of me.

I may wear it, style it, change the color or even texturize it.

But if my hair doesn't represent the essence of my being, I'll cut it all off,

My hair symbolizes nothing (and everything) to me!